Carving Bears and Bunnies

Tom Wolfe

Text by Douglas Congdon-Martin

Schiffer Publishing Ltd

1469 Morstein Road, West Chester, Pennsylvania 19380

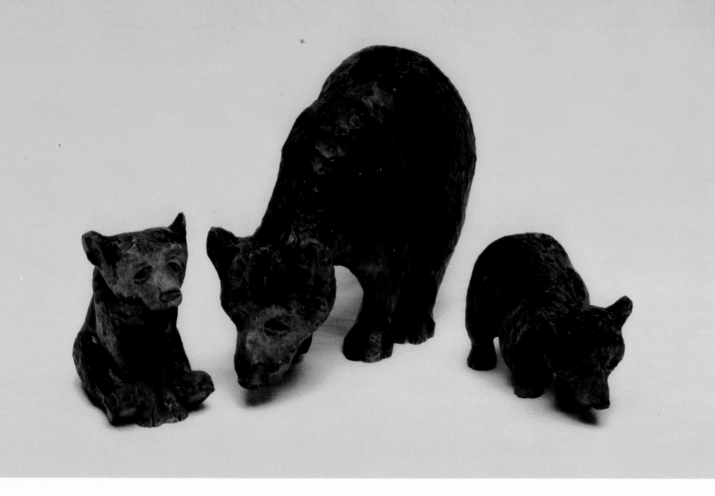

Printed in the United States of America.
ISBN: 0-88740-267-4

Published by Schiffer Publishing, Ltd.
1469 Morstein Road
West Chester, Pennsylvania 19380
Please write for a free catalog.
This book may be purchased from the publisher.
Please include $2.00 postage.
Try your bookstore first.

Contents

Introduction . 4
The Patterns . 7
Carving the Bear . 9
Painting the Bear . 42
Carving the Bunnies 47
Painting the Bunnies 54

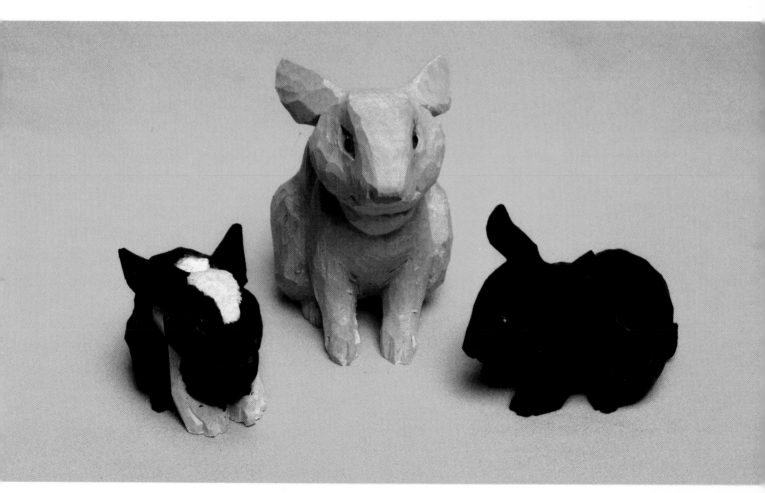

Introduction

For the thousands of people who have already discovered the talent of Tom Wolfe, he needs no introduction. For those who are new to his carving, welcome to an exciting experience. Tom brings years of professional experience to every piece he carves, and he shares that experience with the reader.

This book grows out of many requests we have received for animal carving books in general, and for Tom Wolfe animals in particular. His racoons and hounds have graced the pages of his previous books, *Country Carving* and *"Country Carving: Pig Pickin'."* His bears have found their way into the hearts of people across the nation, both in their original form and as reproductions.

I suspect that given a few minutes to think about it, Tom could carve anything. Beginning with a plain block of bass wood or white pine he creates a menagerie of characters. We selected bears and bunnies for this book for a couple of reasons. First, Tom's studio and shop are in Blowing Rock, North Carolina, in the Blue Ridge Mountains. In that area black bears are a part of the scenery. They delight, and sometimes terrify, tourists as they seek hand-outs or rummage around rest stops looking for leftovers.

The second reason for choosing these creatures is that they have worked their way into the hearts of people. Bunnies and bears are the epitome of "cuddly," and are a favorite of children and adults alike.

These projects are perfect for the person who carves for relaxation. After bandsawing the patterns, they can be completed with the simplest of tools a knife, a gouge, a veiner, and nailset. Tom helps the less experienced reader with the basic skills required for carving. Those are more experienced will value a few of the secrets and shortcuts he has learned over the years, and shares here.

As you will see, the projects can adapted so that your bear or bunny will take on a different character through its size, position, and/or color. Your imagination is all that is necessary to make the changes.

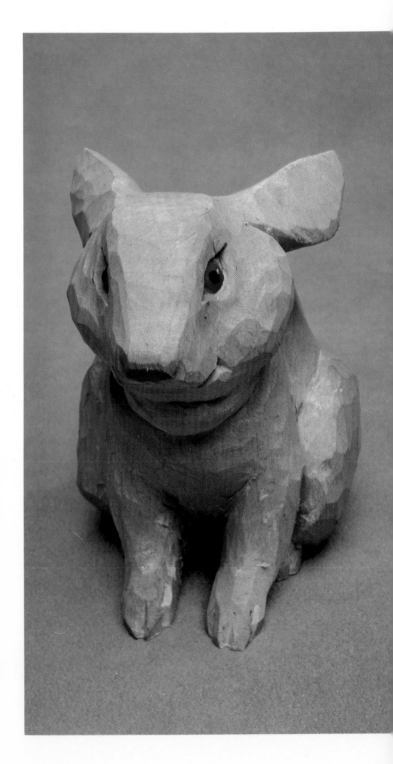

In addition to the two books mentioned above, *Country Carving* and *Pig Pickin','*, Tom has published *Country Dollmaking* with his wife Nancy. It combines his talents at carving with her sewing talents to create interesting dolls.

Two other books by Tom are being published simultaneously with the one you are reading. *Santa and His Friends: Carving with Tom Wolfe,* leads the reader through the steps of carving simple yet fanciful figures. *Country Flat Carving with Tom Wolfe* includes three projects from one-by lumber, including a welcome sign, a rooster potholder holder, and the man-in-the-moon. Don't miss these new projects.

Tom shows his work at many craft events around the nation where he has won recognition for his unusual talent. It is a talent he shares not only through his books, but by giving hands-on craft seminars at schools in the North Carolina school district.

We hope you enjoy his work and that it enriches your own.

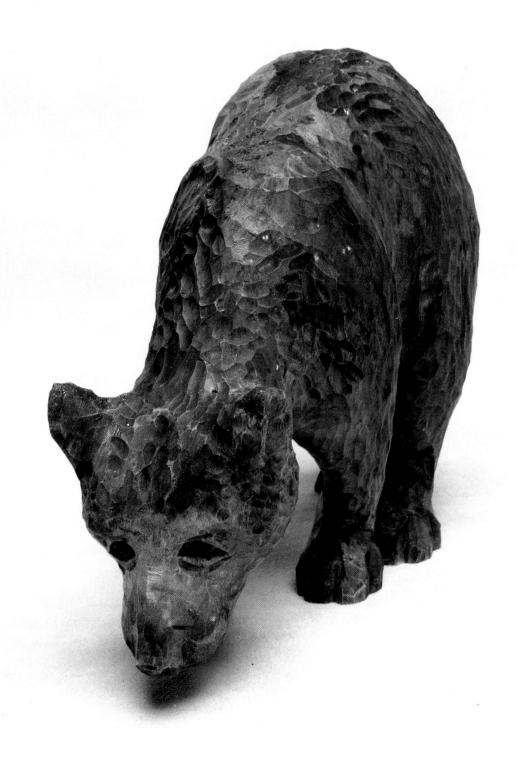

The Patterns

To begin the Bears and Bunnies projects, trace the patterns onto posterboard stock. All the pieces are pictured on the next few pages, and are actual size.

To copy the pattern lay a piece of onion skin paper over it and trace the lines. Then place a sheet of carbon paper (carbon-side down) on the cardboard. Put the onion skin tracing over that and go over the lines again with a pencil or ball point pen. With the proper pressure you should transfer the patterns to the posterboard which you can then cut out.

While you may choose other woods, I find that bass wood is best for painted figures. You may also wish to do these carving in a hardwood and finish them naturally.

Dimension for the Wood Blocks

Adult bear—H: 6½″, L: 10″, W: 3½″
Seated cub—H: 4″, L: 4″, W: 2¼″
Standing cub—H: 3¼″, L: 4½″, W: 2¼″
Adult bunny—H: 3½″, L: 4″, W: 2¼″
Baby bunnies—H: 2¼″, L: 3″, W: 1¾″

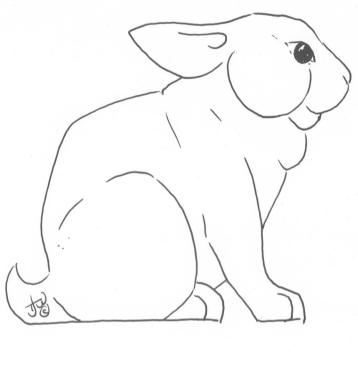

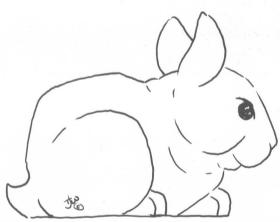

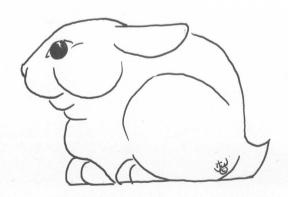

Carving the Bear

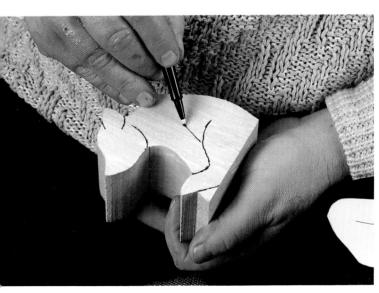

Cut the sitting cub blank with a band saw. Mark details on the blank.

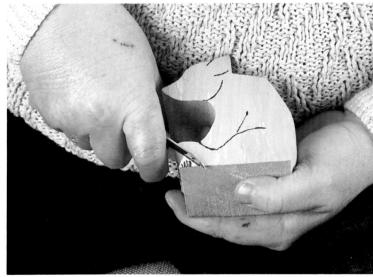

Cut a stop at the bottom of the back paws.

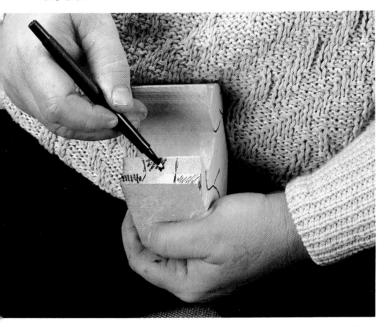

Mark the toes, keeping the back feet at the outside and a place for the front paws in the middle. Blacken the excess wood to be removed.

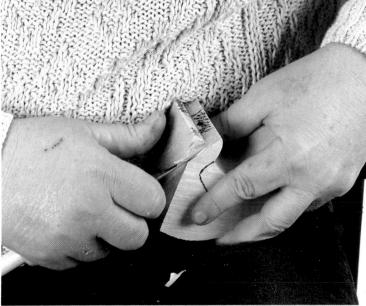

Remove the excess wood by cutting back to the stop. Repeat this action of cutting the stop and cutting back to it until the excess wood is removed.

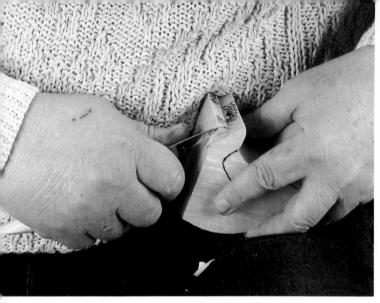

Do the same on the other foot.

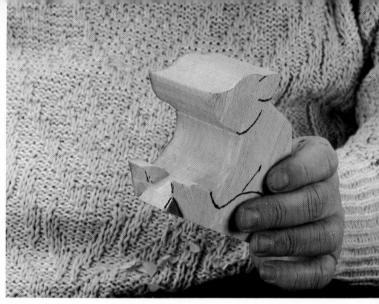

The general shape of the legs and paws now is defined.

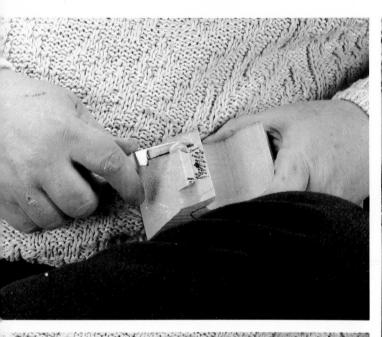

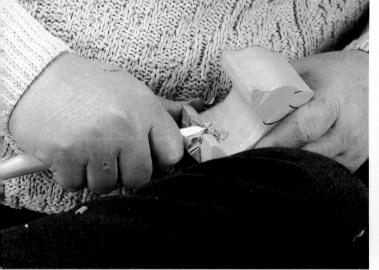

Clear the space between the back legs. Be sure not to remove the front paws.

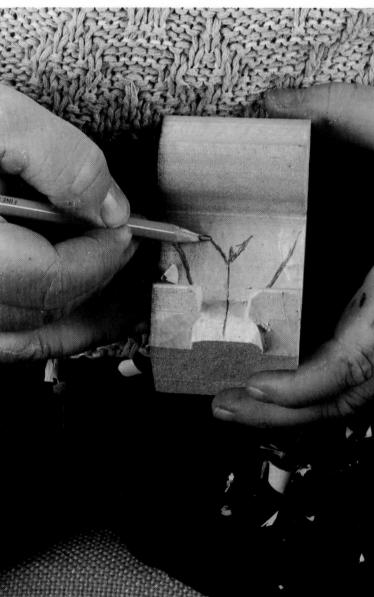

Draw in lines for the front legs.

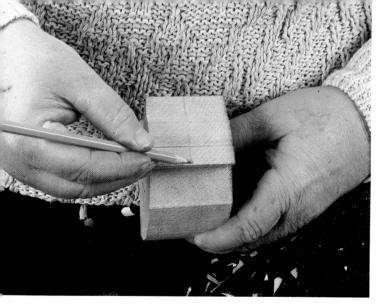

Make a center line around the back from nose to tail.

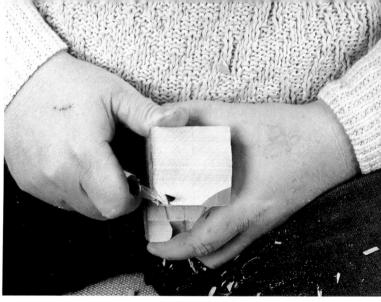

Narrow the head from the nose area back to the tip of the ear. Be sure to leave plenty of width for the nose, since bears have wide noses.

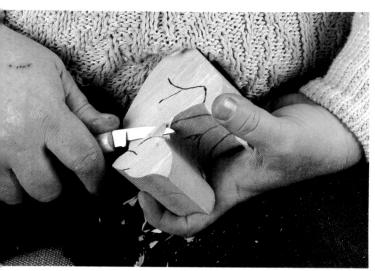

Go around the neck and cut away to define the head and the neck...

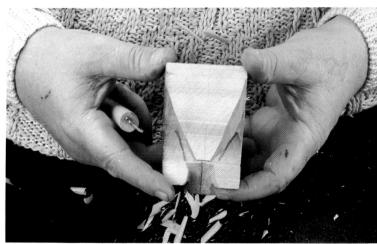

The view from the top of the head when you've removed the excess should be triangular, something like this.

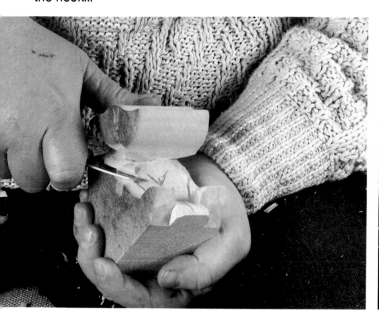

and give general shape to the shoulder.

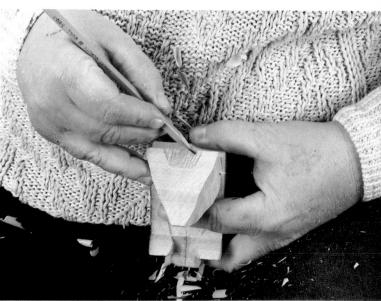

Mark the space between the ears...

11

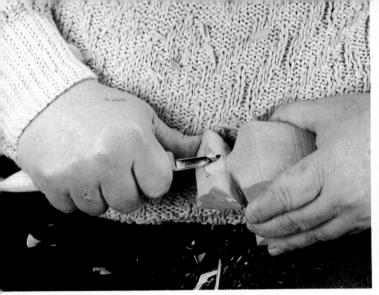

and remove.

Mark first, then pop off the excess wood.

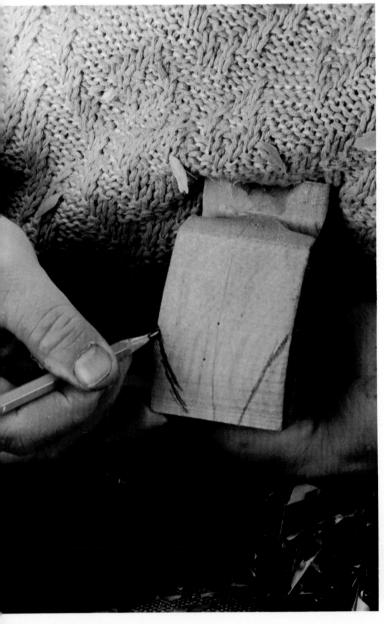

Round the corners of the hips.

Form the tail.

Remove the area in front of the back leg and beside the front leg.

Use a gouge to shape the back legs.

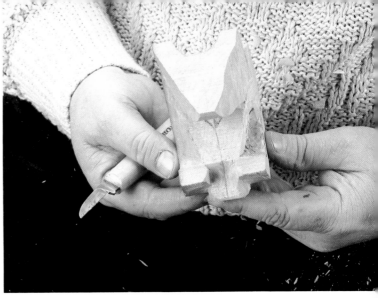

and straight on. Now do the other side the same way.

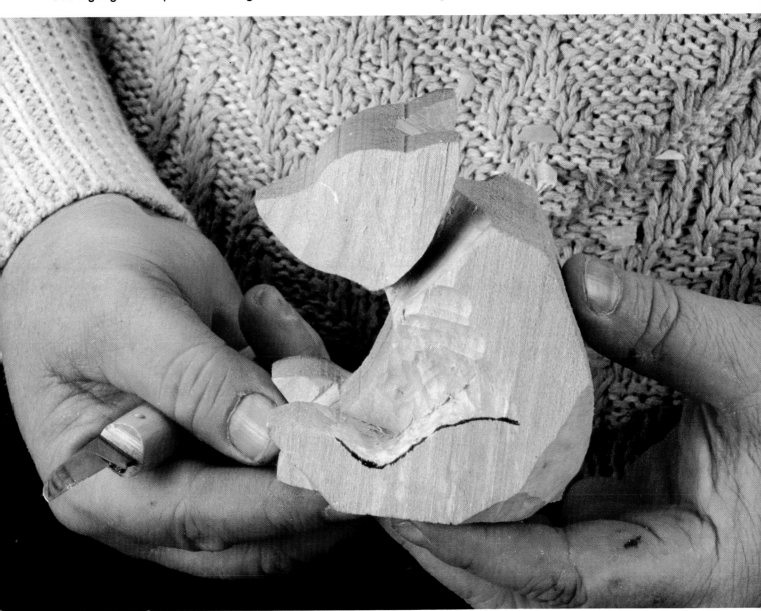

Bring the gouged area up to the side of the front legs, shown here in profile...

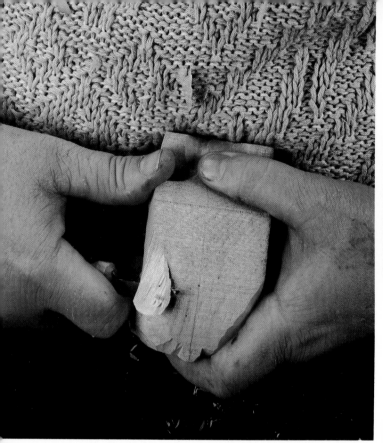

Round off the back, popping off excess wood.

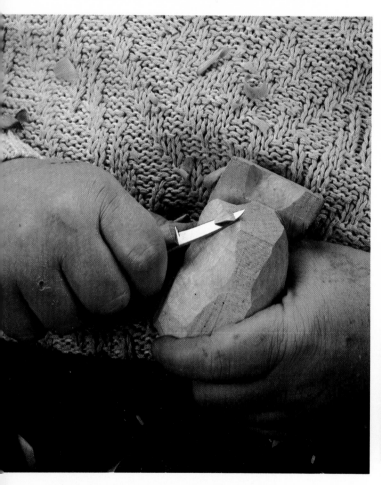

Round off the shoulder toward the neck.

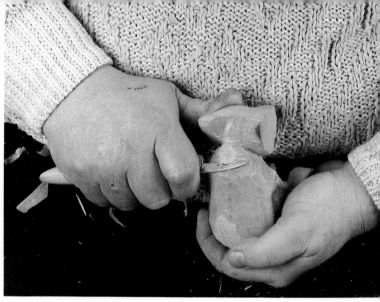

Trim down the cut marks on the back.

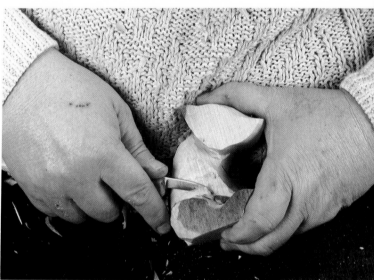

Further shape the sides.

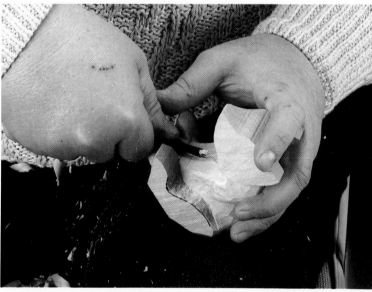

Follow the lines on the front legs with the v-gouge veiner, to get a nice clean line.

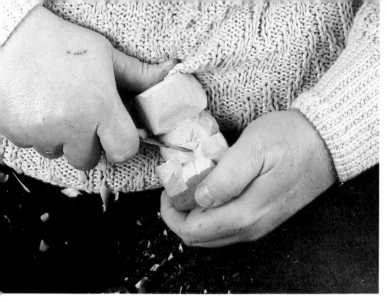

Go back and separate the legs more with a knife.

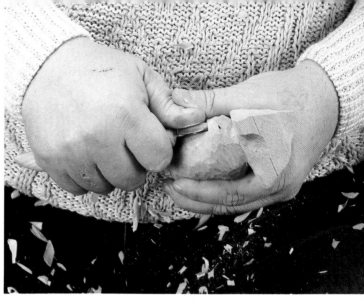

Shape and clean the carving.

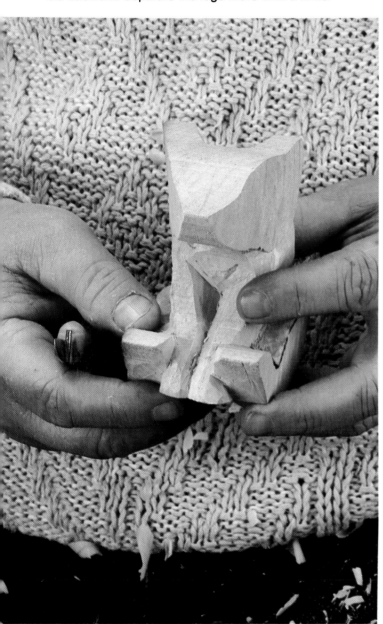

Continue to round and define the front legs.

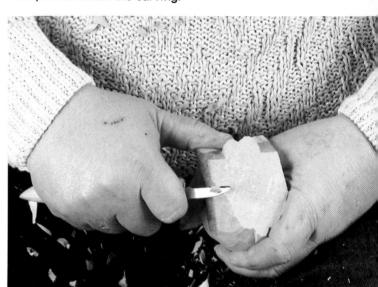

Shape the bottom of the rear legs.

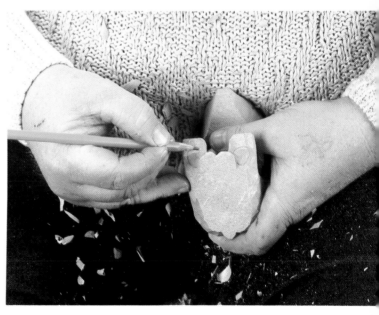

Draw pads on the hind feet

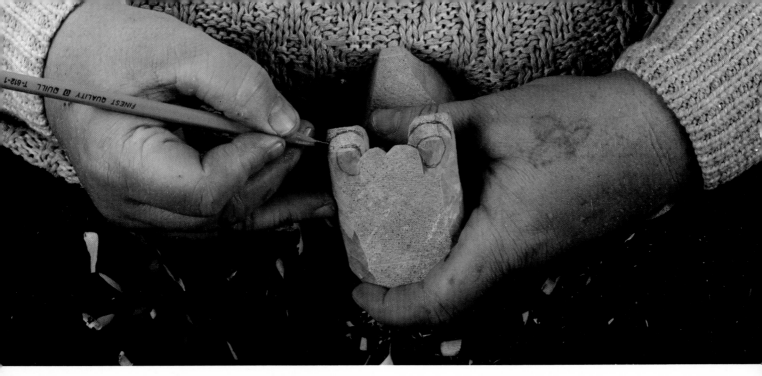

Mark the line of the toes, at the appropriate size. This helps set the size of the feet.

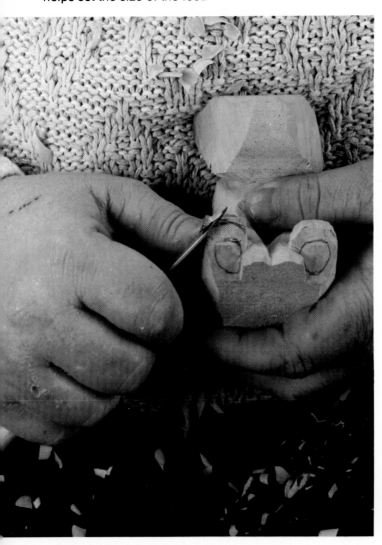

Trim the excess at the ends of the toes.

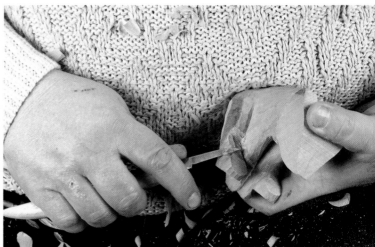

Round off the outside of the paws.

Shape the tops of the back paws.

Round the side of the haunches.

The front paws are too pointed and do not appear flat. Remove the area marked,

Mark the ears...

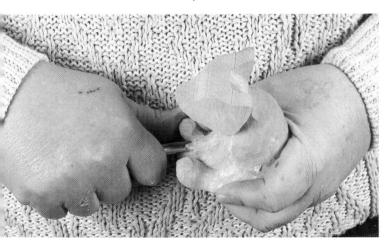

Use a gouge for this.

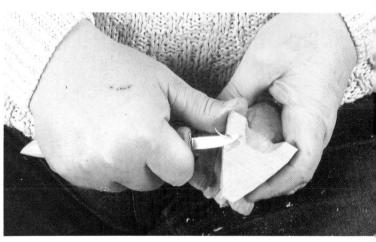

and begin to trim the basic shape.

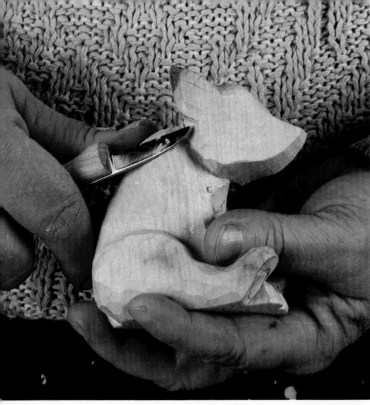

No matter what kind of animal you are carving, whether a bear, bunny, or human being, it is important to remember that the ear placement is at the back of the jaw.

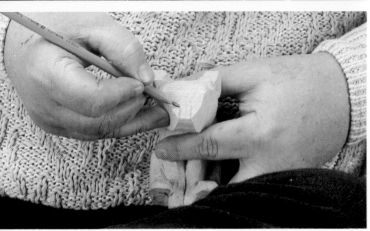

Mark the line of the muzzle. Keep this width or it will end up looking more like a beak.

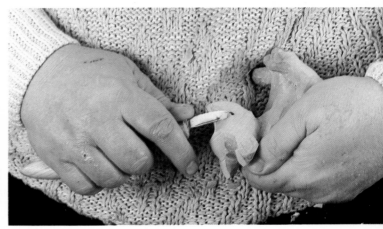

Round the sides of the muzzle...

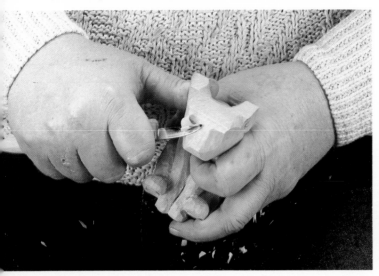

Trim back to the line of the eye.

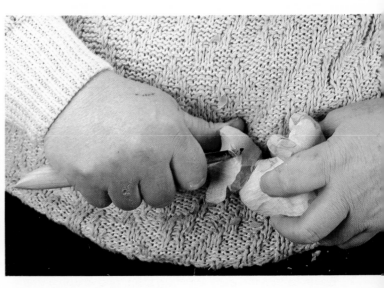

and continue under the jaw.

18

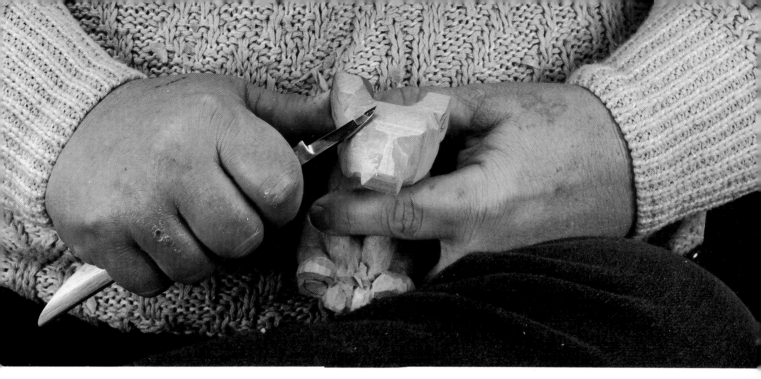

Round the head all around.

Carry the rounding down the chin to the neck.

so we'll round it off.

Begin to trim the ears, thinning them and shaping them. This ear is far too pointed for a bear...

Mark the inside of the ear...

then use a gouge to remove the excess.

Cut back to it to make a v-line.

Mark the nose and the mouth.

Do the same thing at the mouth line.

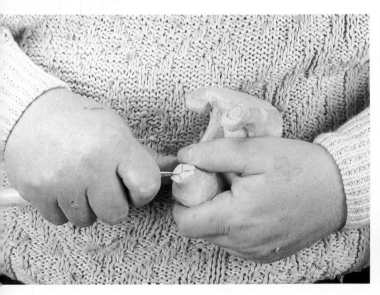

Make a straight mark at the nostril...

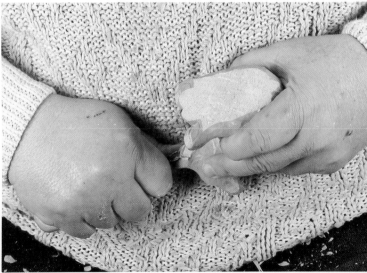

Carve the line in the middle with a v-gouge.

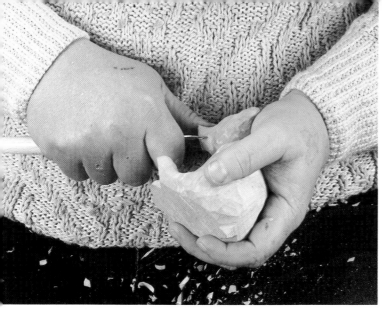

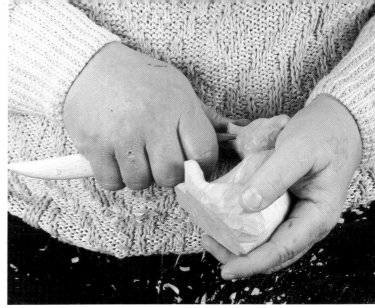

Bring the mouth around the sides with a straight cut.

Putting a little nitch at the back of the mouth...

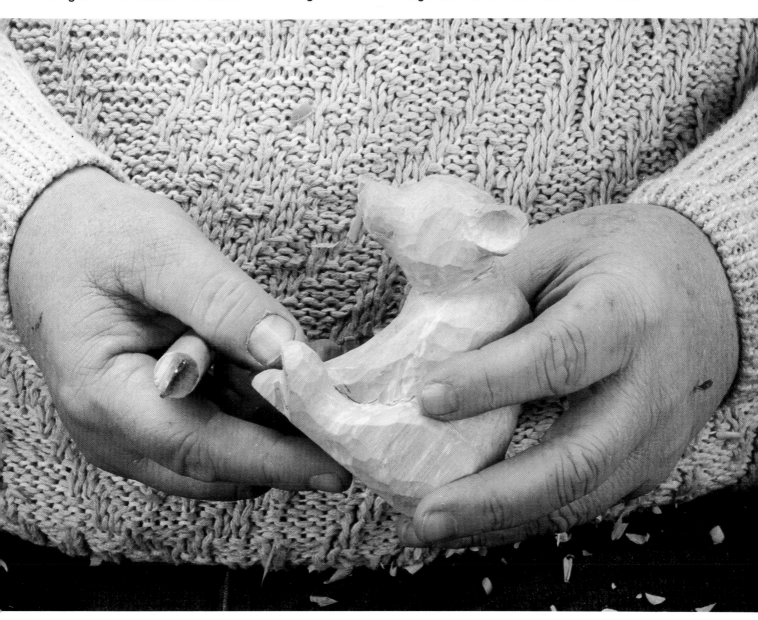

gives the bear a smiling, friendly look.

21

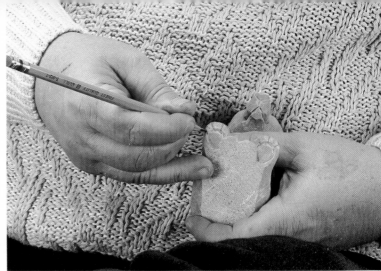

Mark the toes...

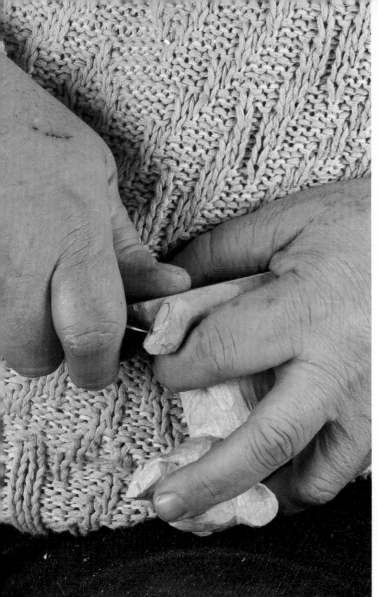

Cut a stop around the pads of the rear feet.

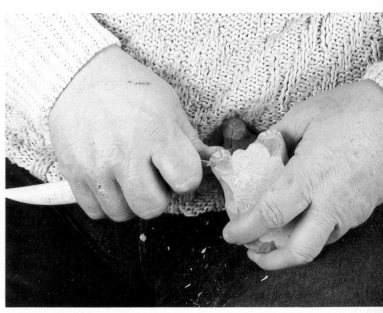

and notch them out.

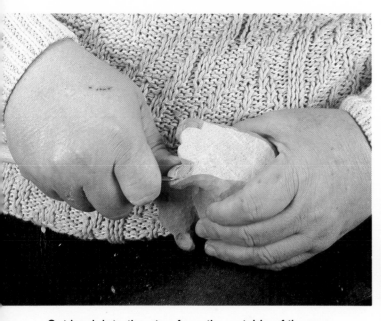

Cut back into the stop from the outside of the paw.

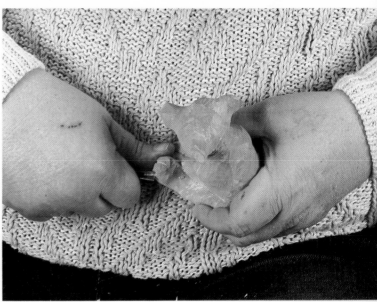

Carry the lines up the front of the paw with a v-gouge.

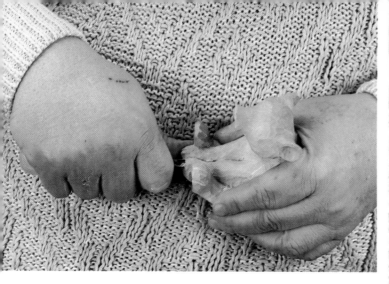

Also use the v-gouge to delineate the toes in the front paws.

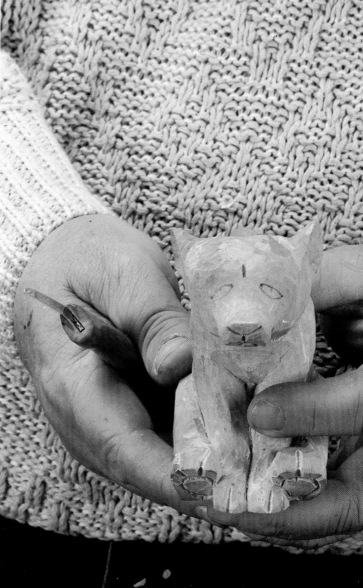

Draw in the lines.

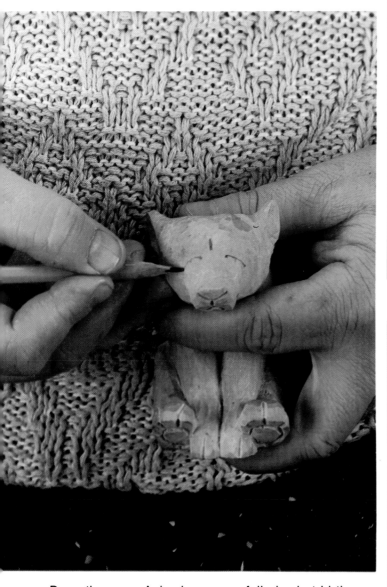

Draw the eyes. Animal eyes are full-sized at birth, so avoid the urge to make them smaller in the cub than in the parent. The center mark needs to be put back in the middle of the forehead of the bear so the eyes go in the right place.

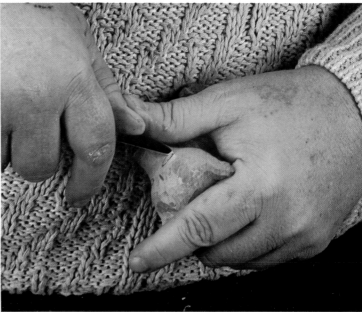

Make two cuts in the outside corner of each eye...

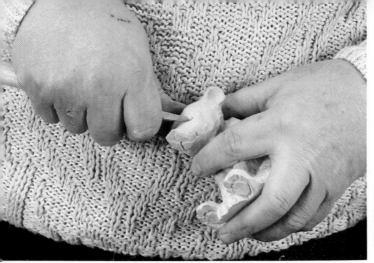

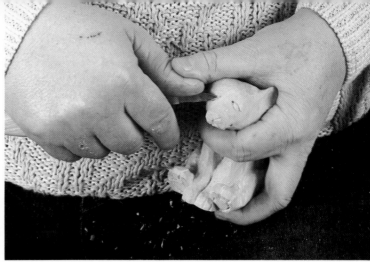

and notch it out. Do it at such an angle so the eyeball has a rounded shape.

then cut back to it to round the eyeball.

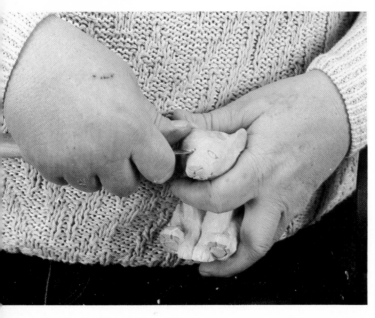

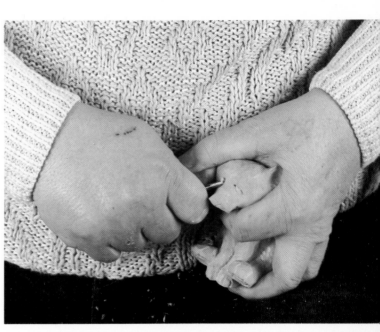

Do the inside corners the same way.

Cut a stop all around the eye opening...

Take a veiner and go around the top and bottom eyelids.

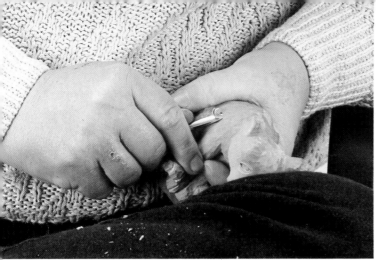

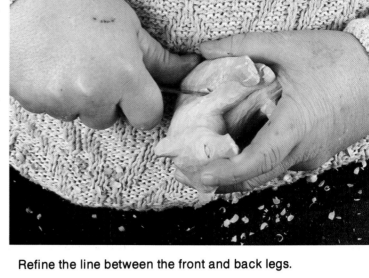

Use a gouge to put hairline marks in the bear cub. All the lines will run up from the bottom to the back and then to the top of his head. While you are putting in these hair marks, you also can take care of any rough spots in the carving.

Refine the line between the front and back legs.

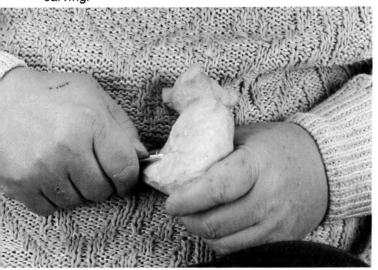

An example of this is that I need a groove behind the front leg, which I can do now.

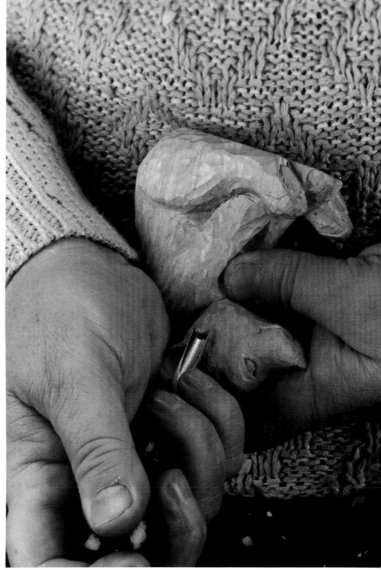

Do not work in any one place. Do some work in one area, then go to another. This helps keep the work even.

Add some hair lines around the ears and cheeks. There are other ways to finish the piece. You could sand it smooth or cut the hairlines with a knife. It depends on the desired effect and the type of wood you are using.

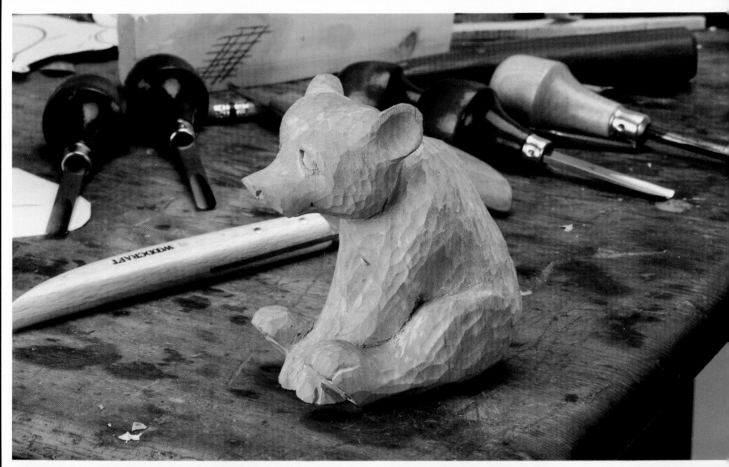

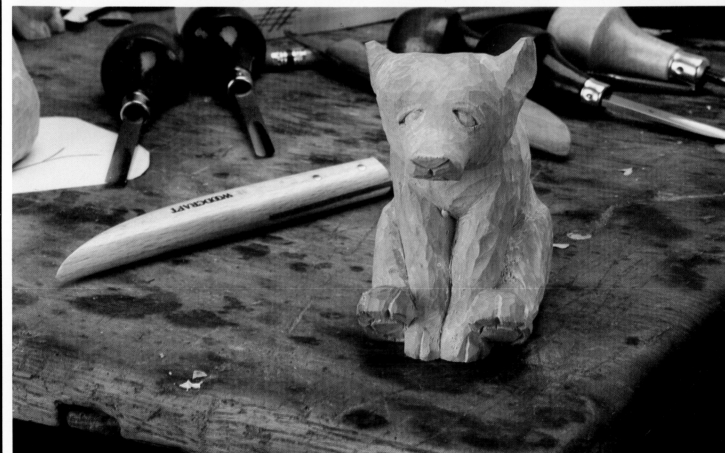

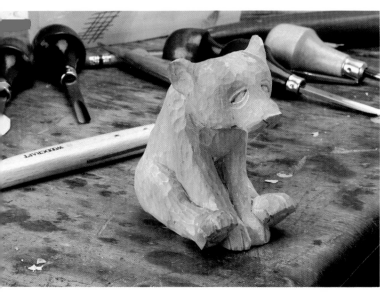

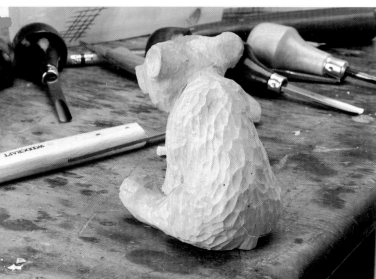

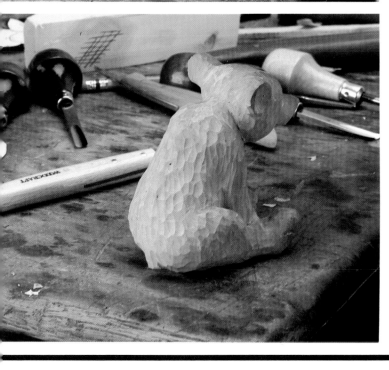

The carved bear cub.

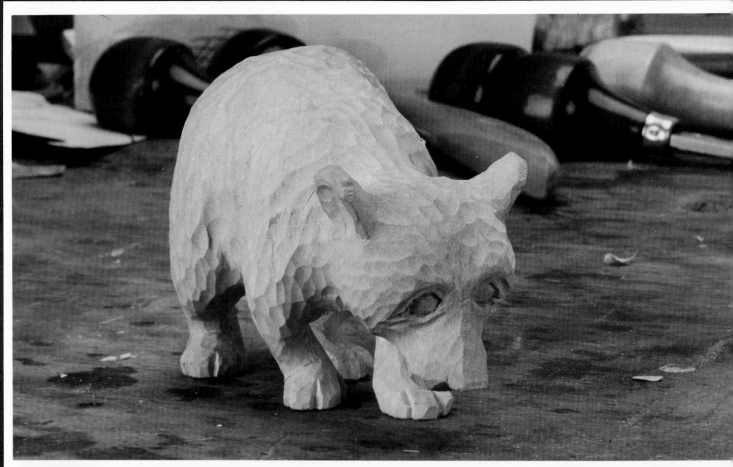

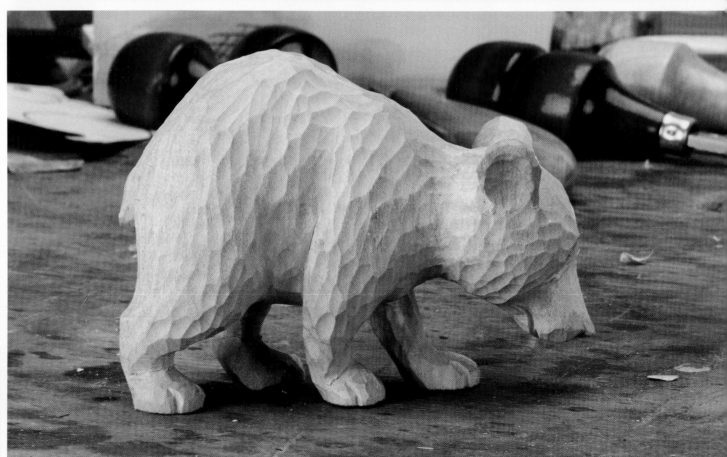

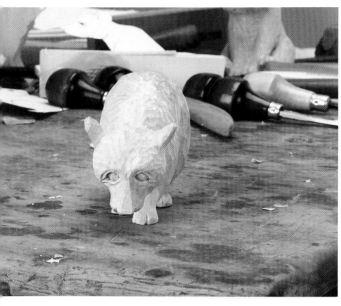

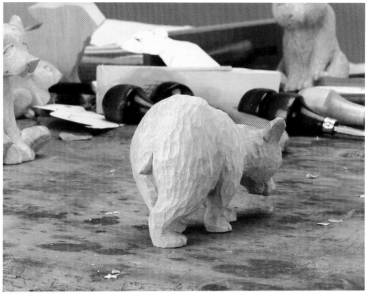

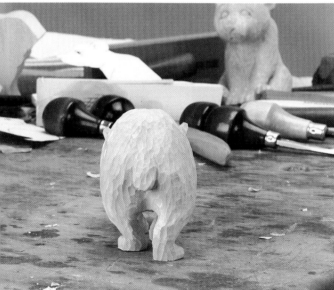

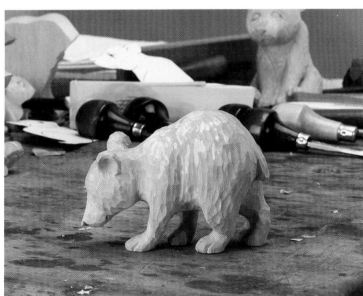

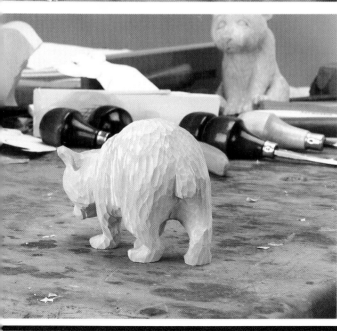

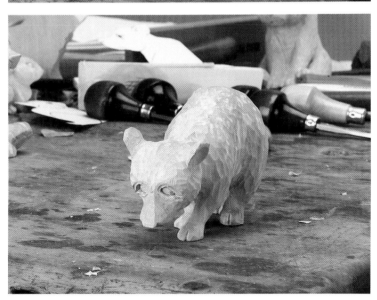

Our cub's sister.

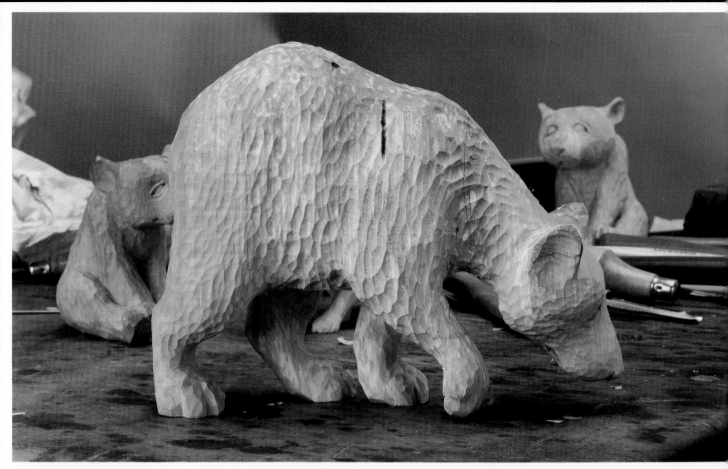

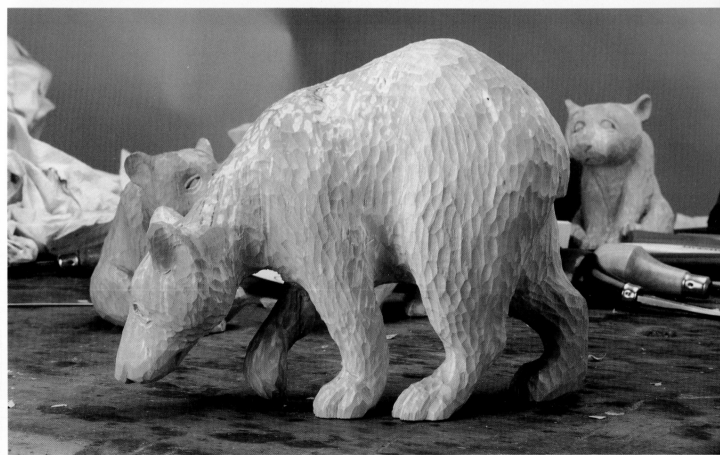

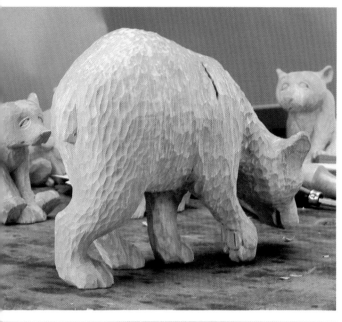
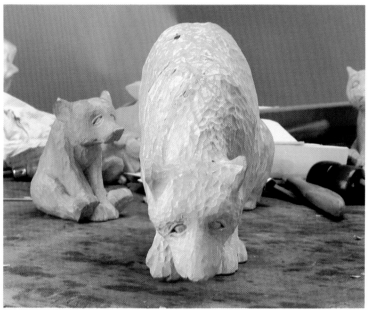
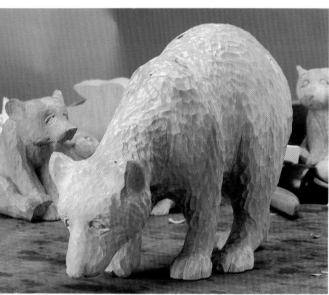
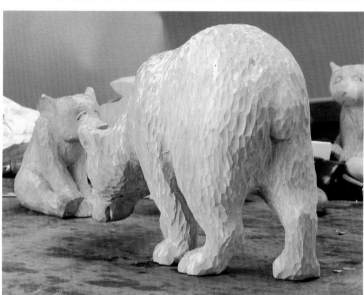
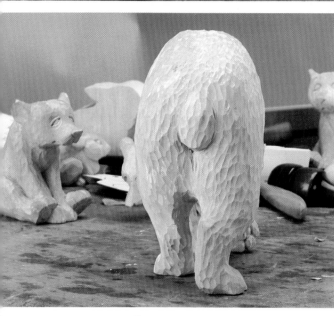
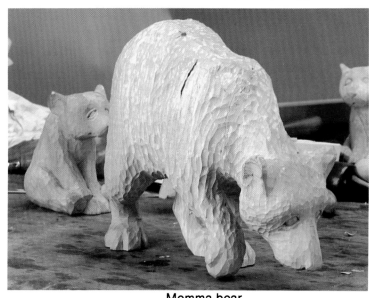

Momma bear.

Painting the Bear

The paint I use is alkyd thinned with turpentine. This gives good penetration without much bleeding. The brushes are a good grade, usually sable or camel.

Use burnt sienna on the cubs. First do the muzzles, the inside of the ears, and around the eyes. Do not put it on the nose because we want it to be really black

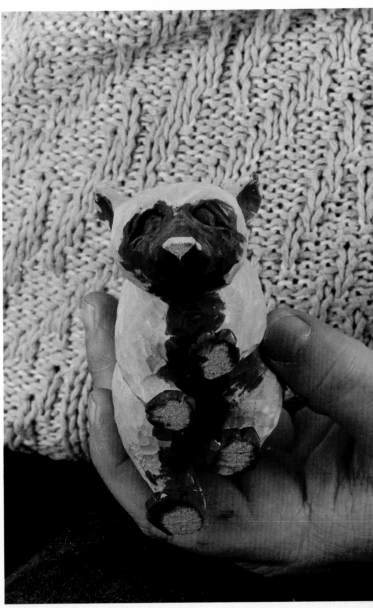

Here is the standing cub with the brown undercoat.

Dab the burnt sienna around the chest and extremities. Some of this will be covered with black.

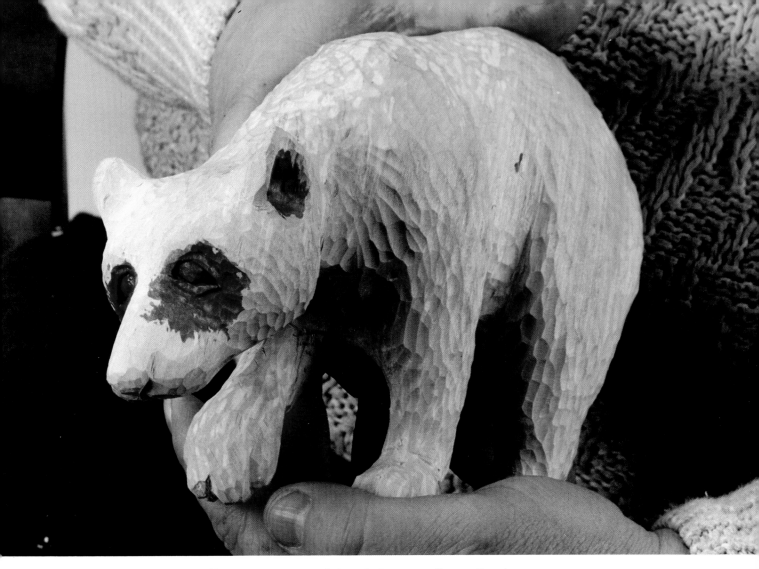

Do not use as much burnt sienna on the mother bear.
Paint only around the eyes and in the ears.

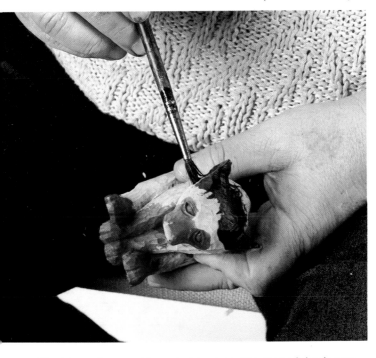

Start anywhere and apply black to the rest of the bears.

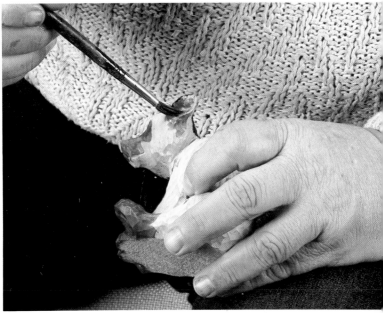

When you get near the brown, take pure turpentine and
wet over the brown. This saturates the area and keeps the
paint from penetrating too deeply.

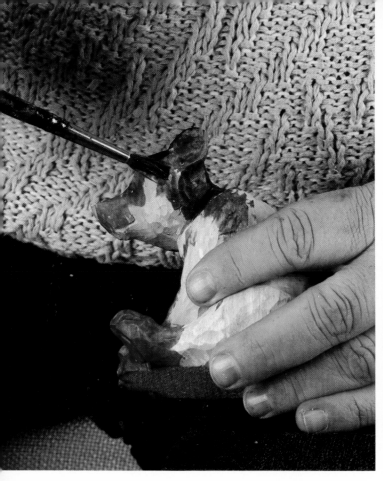

Then go over the area with black. The turpentine lets the brown show through with only a tint of the black.

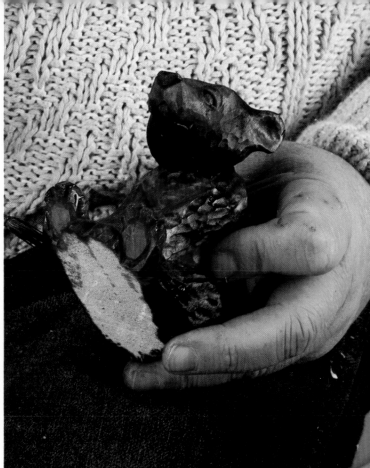

The foot pads should not be overpainted with the black.

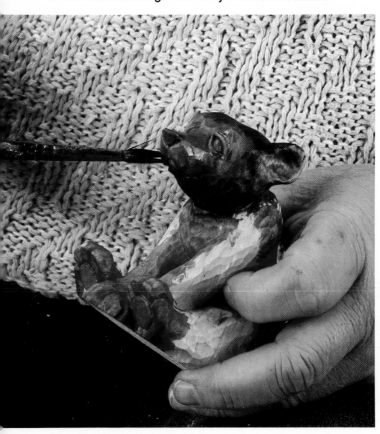

This allows for a good blending of the paints.

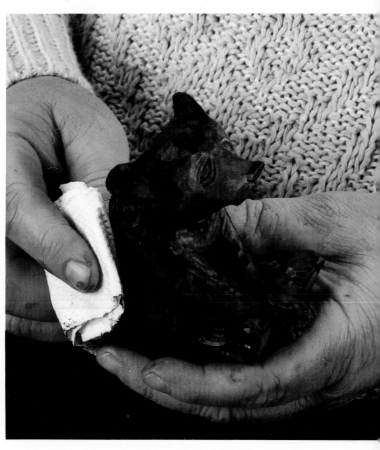

Rub the bear down with a paper towel or a rag.

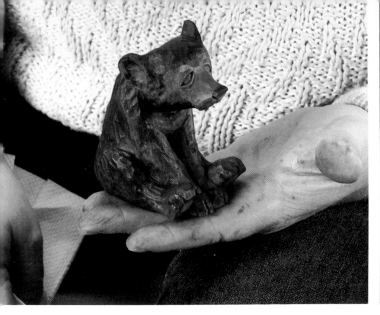

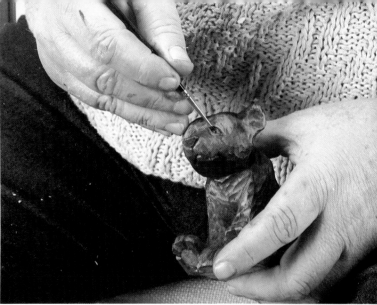

The painting is almost finished. The eyes probably need to be black.

Use a concentrated pigment and a small brush to apply black paint to the eyes.

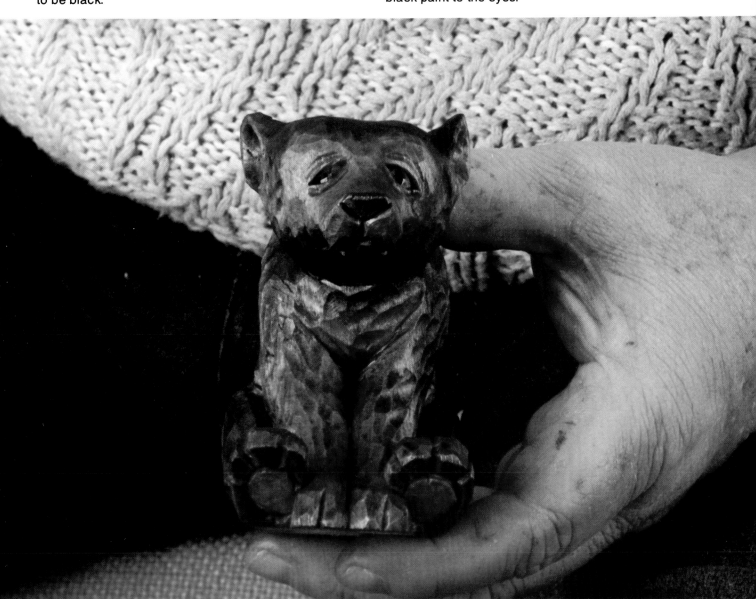

The finished bear cub.

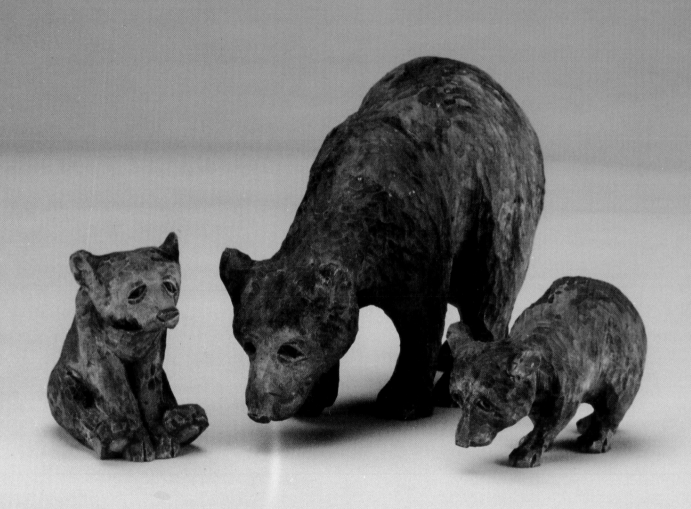

The bear family

Carving the Bunnies

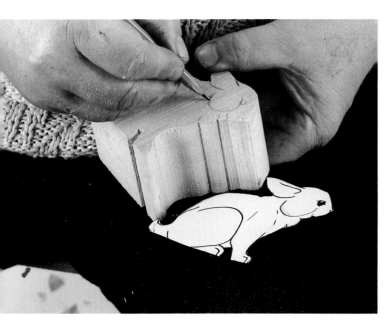

Using the pattern, draw the features on the side of the blank.

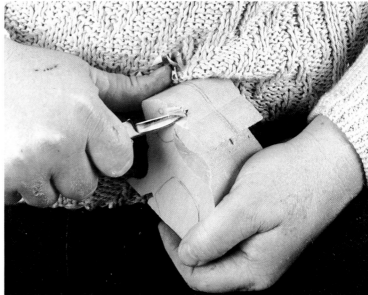

Start rounding the back below the ears.

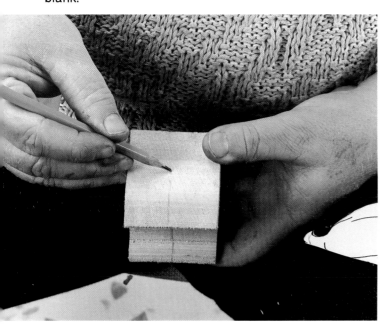

Draw a center line all the around the bunny.

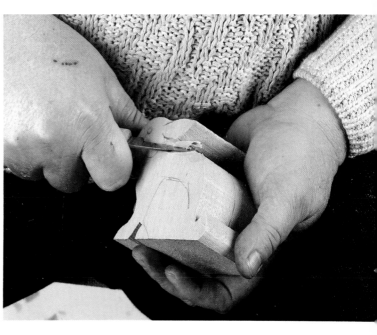

Trim a notch at the front of the ears to define the ear line.

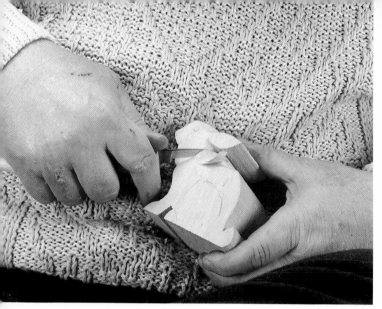

Begin to round the neck...

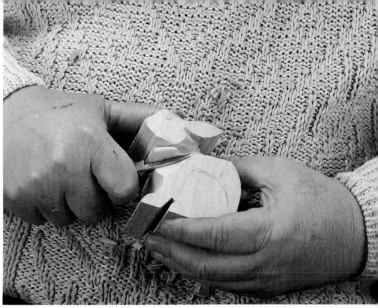

and go all around. Then round the front shoulder.

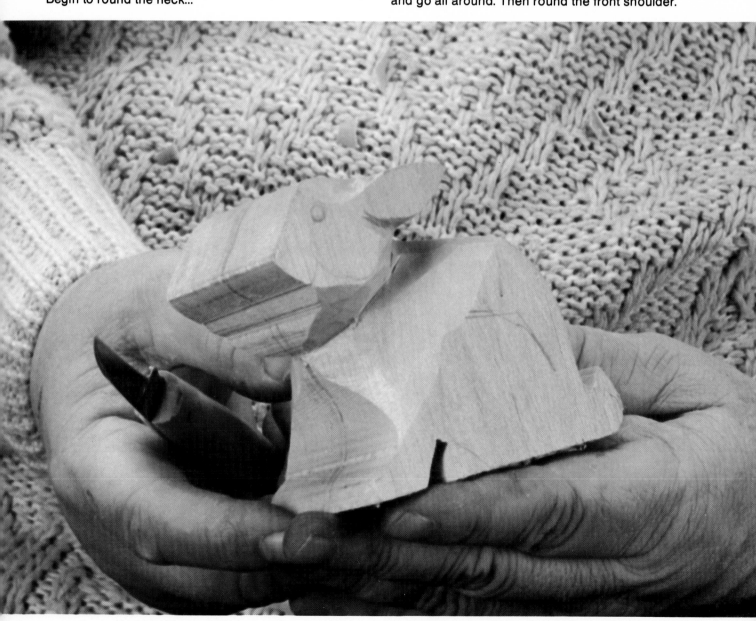

The neck is carved down and runs into the shoulder.

Narrow the head. Keep the points of the ears at the full width of the blank and work toward the nose.

Knock off the edges of the haunches. Be sure to leave enough in the middle for the tail.

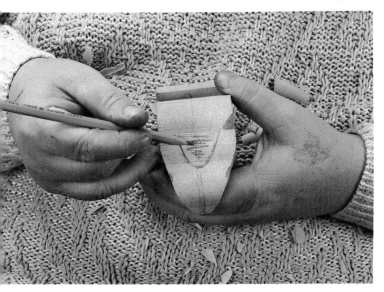

When you're finished, the head should look something like this from the top. The marks for the ears have been drawn in.

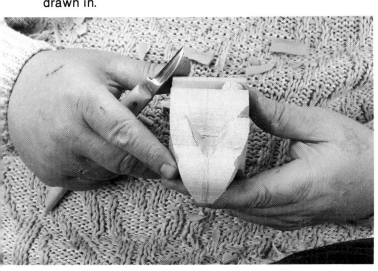

Remove the darkened area between the ears.

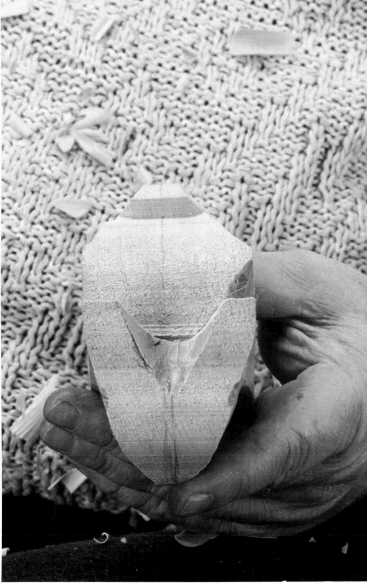

The shape should now look like this from the top.

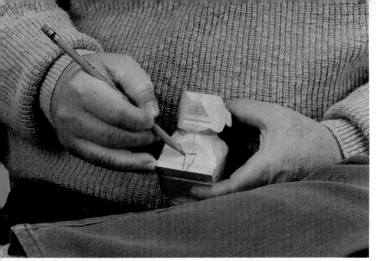

Mark the area between the front legs.

Mark the width of the front legs.

Beginning between the front feet use a knife...

to chip the area out.

Trim the excess wood away.

Round off the back.

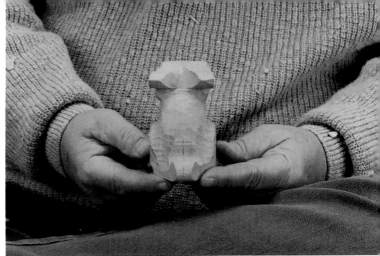

When you've done this the rabbit should look something like this from the back...

Mark the haunches of the back legs.

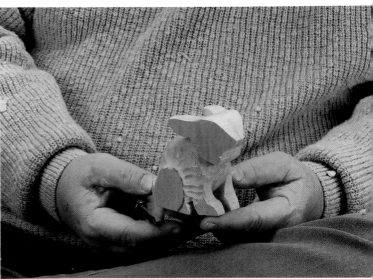

and like this from the side.

Use a gouge and cut from this line into the body.

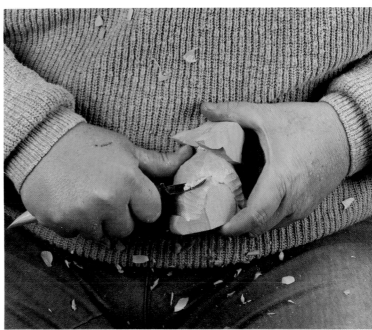

Round the back and smooth the marks from the gouge.

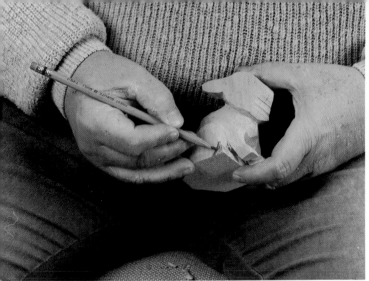

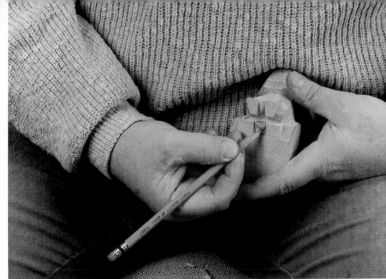

The back feet of the rabbit are positioned under the body, so it can get a fast start when alarmed. Mark the area to the outside of the back feet to be removed.

From underneath the rabbit, mark the space between the back feet.

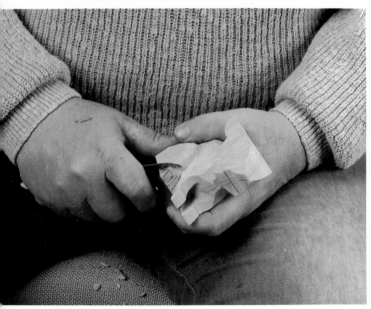

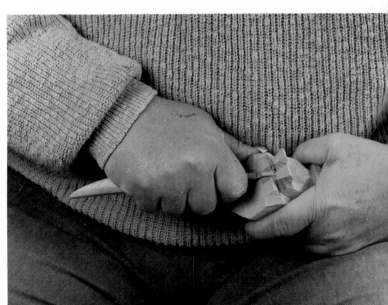

Cut a stop on the haunch line...

Remove the wood between the back feet.

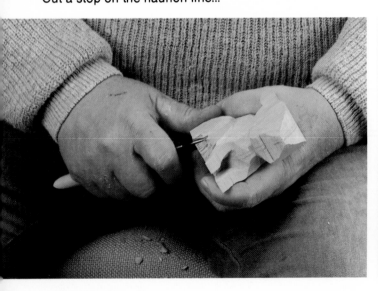

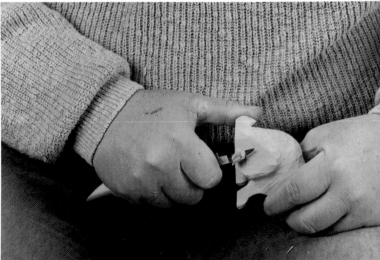

and cut back to it.

Round the haunches.

42

Define the tail and trim to it.

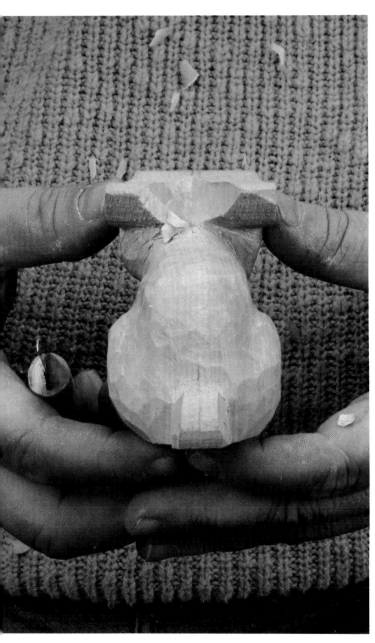

The back view.

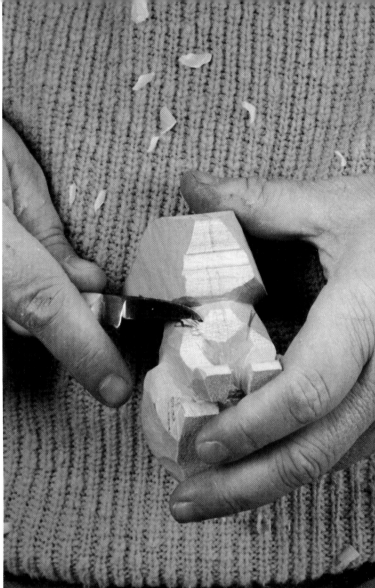

Go over the rabbit, smoothing out rough spots and giving further shape. Keep moving while you do this and avoid concentration in one place. If you get too focused, your piece soon will look lopsided.

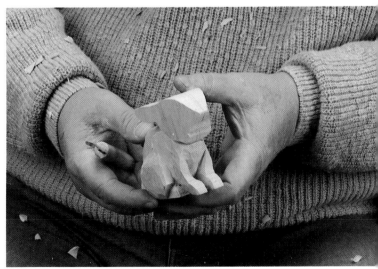

It is time to work on the face.

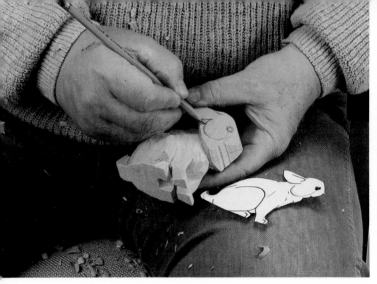

Use the pattern to draw in the facial features. This helps you keep the symmetry you need.

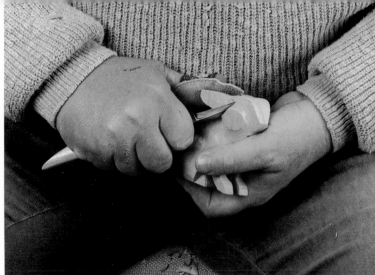

Leave the cheek alone for now. Continue to carve around it.

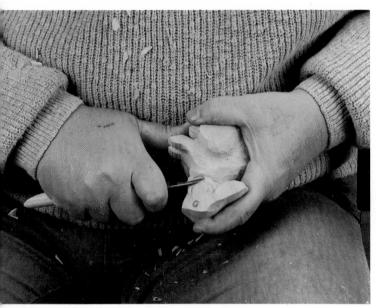

Cut around the lines of the cheek.

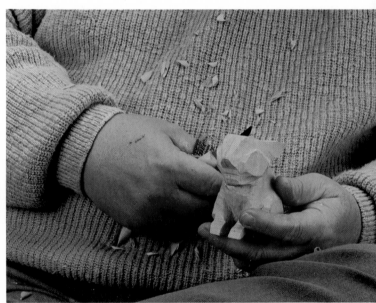

Keep going over the head until it looks the way you want it. For some reason a rabbit easily can turn mean looking, so be careful. The meanness usually comes from the eyes.

Taper the snout slightly.

Start rounding the cheeks, making them more refined.

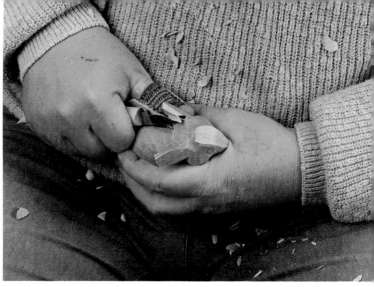

then carve the backs of the ears.

As you carve away the drawn features of the head, replace them so you can keep perspective on the work.

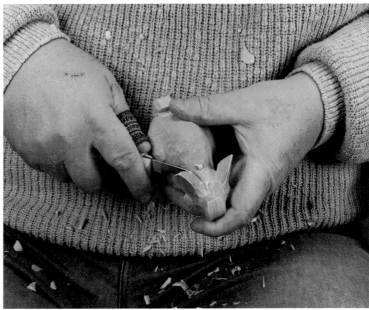

Bring the back in at the neck and trim and smooth the neck as well.

Shape the inside of the ears...

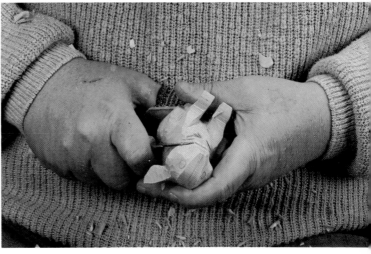

Round the cheek some more. Blend it into the muzzle and neck.

45

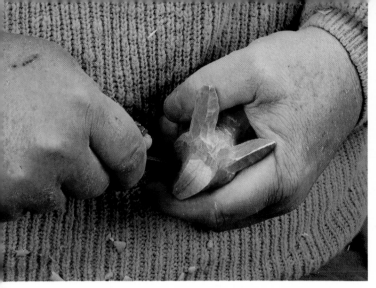

Mark the eyeball with a nailset, pushing it in and twisting back and forth.

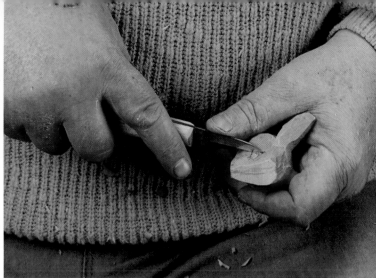

Cut a "v" at both ends of the eye by first cutting a stop...

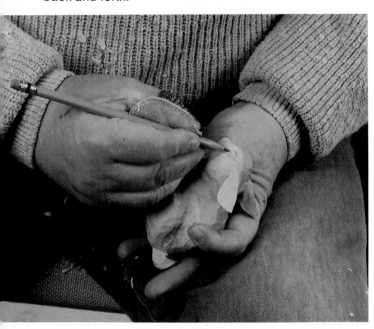

Draw the line of the eye following the line of the muzzle.

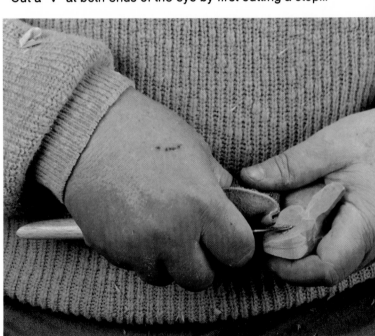

and then carving back to it at a very flat angle. This gives the look of the eyeball going back into the socket.

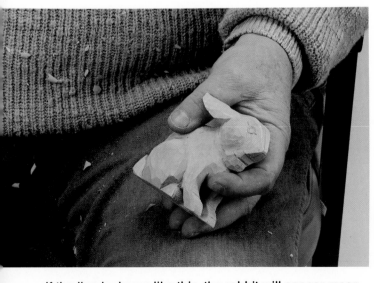

If the line is drawn like this, the rabbit will appear mean.

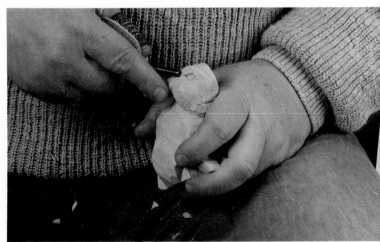

When you've carved the "v"s go back over the iris with the nailset to bring it out again.

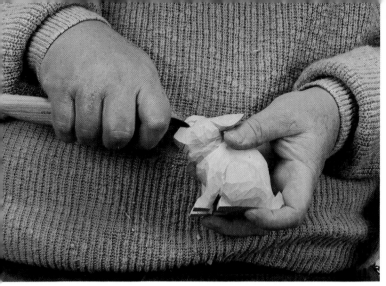

Refine the upper and lower eyelids with the knife.

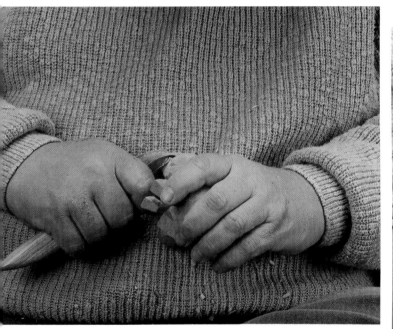

Notch out the bottom of the muzzle...

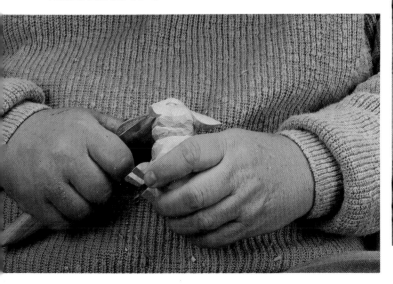

to arrive at this appearance.

Refine the chin area. Since this is to be a domestic rabbit the chin will have more fatty tissue. A wild rabbit would be leaner.

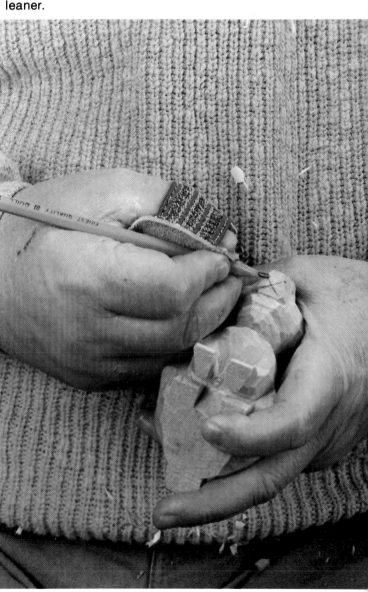

Mark the nose and mouth. In rabbits the nose comes down to the mouth, making it very easy. Simply mark an "x."

Cut a little v-shaped groove in the "x' using your knife.

Shape the tail with a slight point at the top, because it is upright.

Carve a little smile in the corner of the mouth.

This can be done with the knife...

Dress-up the head. Remove saw marks and refine shapes.

or with the gouge. The knife probably is safer, as it gives you more control and less chance of breaking off the tail.

A little gully down the center of the tail seems to make it look better. I don't know why this is so, since in reality the opposite happens on the rabbit. But it works.

Round the feet off.

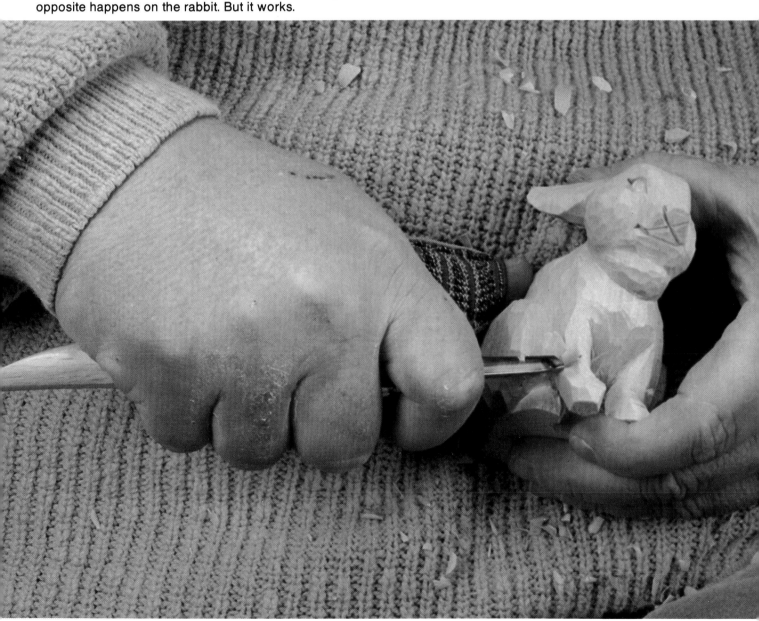

Trim and round the front legs and feet.

Cut a groove between the front and back legs to make them more distinct.

Use a gouge to show where the front leg comes up to the shoulder.

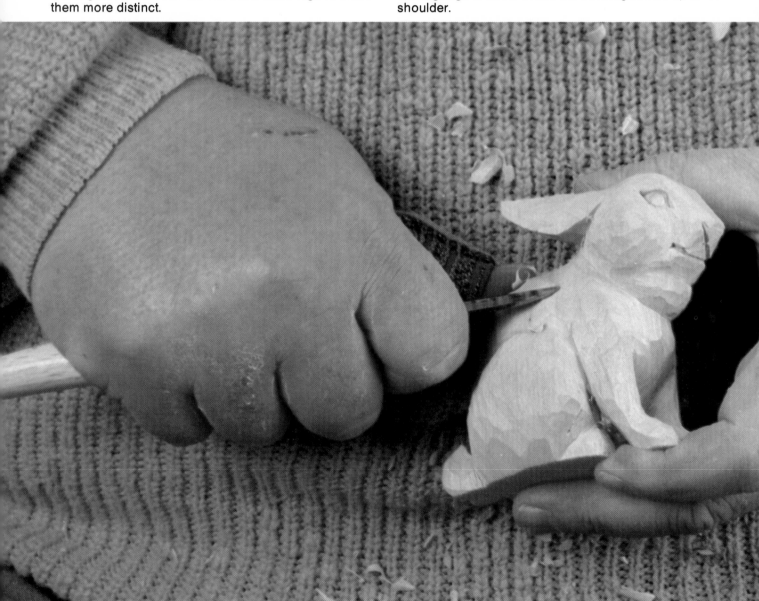

Round off the gouge mark.

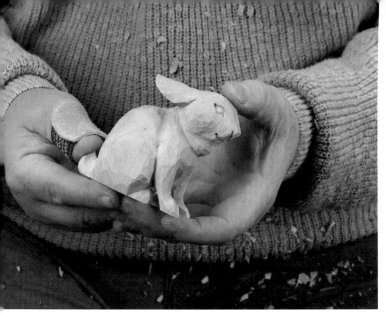

This shows the shoulder definition.

Go all over the rabbit, and refine and correct any errors.

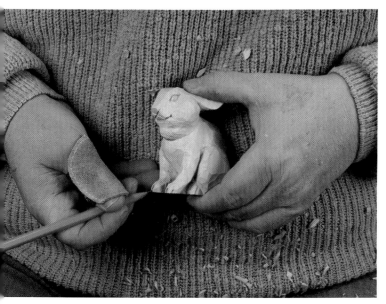

Mark the toes all around. There are four toes on each foot, though on the back only three may show.

We forgot to open up the inside of the ear. Use a v-gouge first...

Use a v-gouge to bring the toes out.

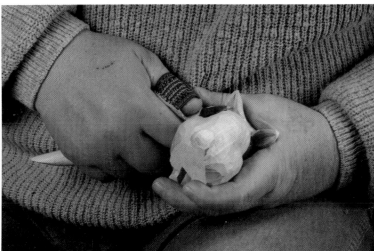

Then trim it up.

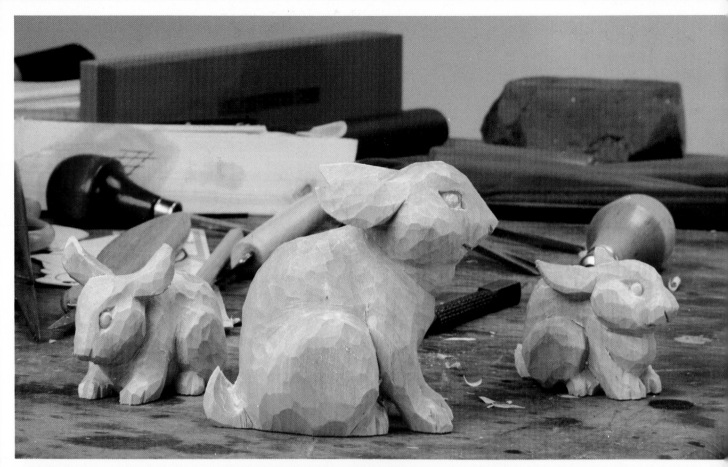

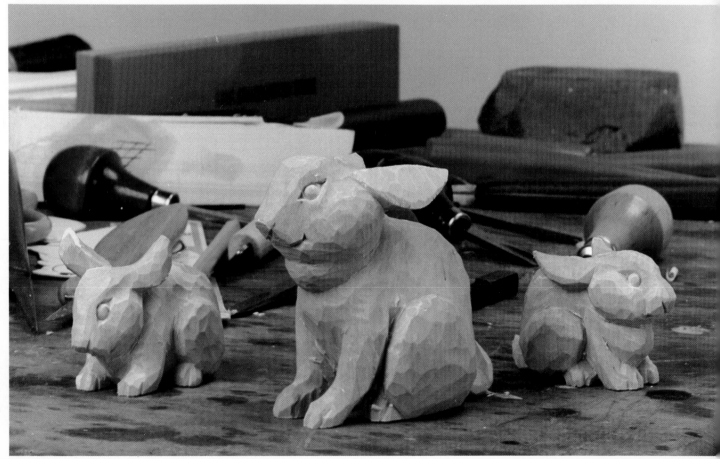

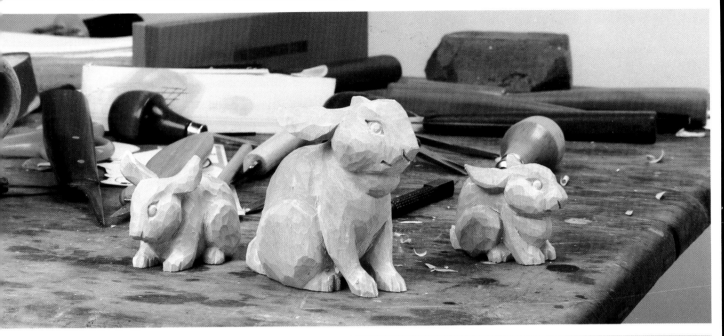

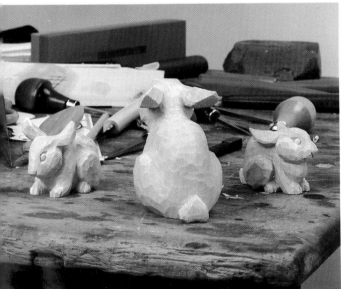

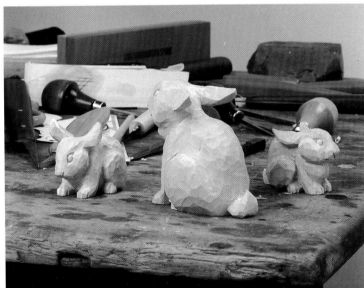

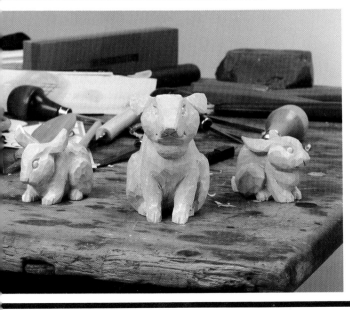

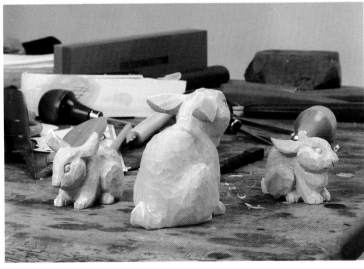

The finished carving.

Painting the Bunnies

The paint I use is alkyd thinned with turpentine. This gives good penetration without much bleeding. The brushes are a good grade, usually sable or camel.

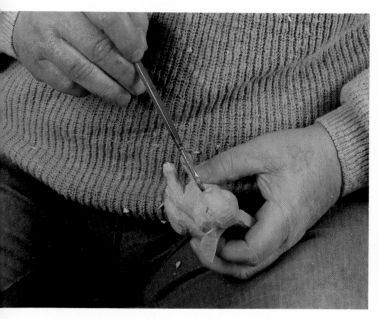

When painting in white, be sure to remove all pencil marks or they will show through. Begin painting the pinkish areas of the bunny with a commercial flesh tone. Start with the nose and the front of the muzzle.

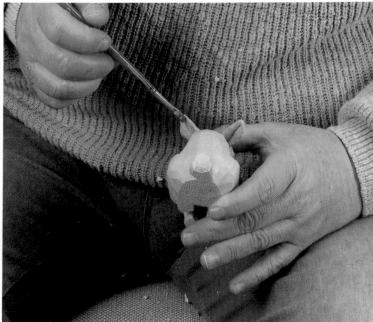

and the inside of the ears.

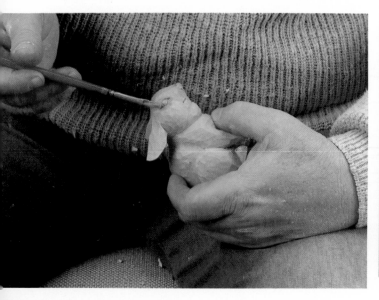

Continue with the eyes...

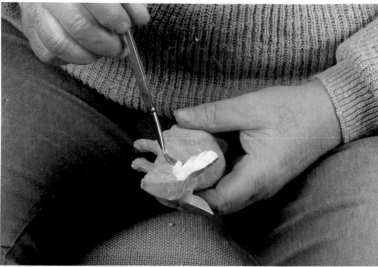

Use a bigger brush to apply the white. Begin with the outside of the ears.

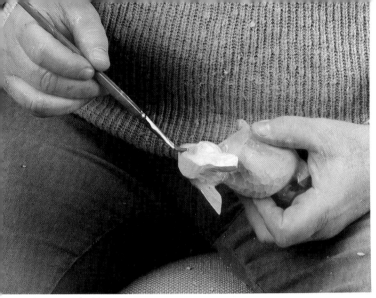

Paint the face, but leave the eyeball untouched. Overpaint and brush out the pink areas around the eye.

Add a touch of red to the eyes from the cap of the paint bottle. This gives it a greater concentration of pigment and less likelihood of running. Use your thumbnail as a palette.

A black dot will form the pupil. Again, use your thumbnail as a palette.

On the muzzle leave the nose pink, but overpaint the surrounding areas.

Finally, add a white glint to the iris. Put it at the same position in each eye.

55

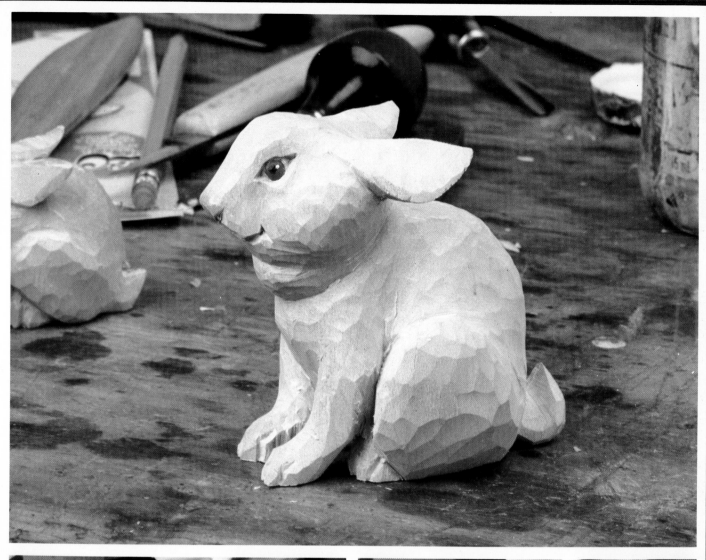

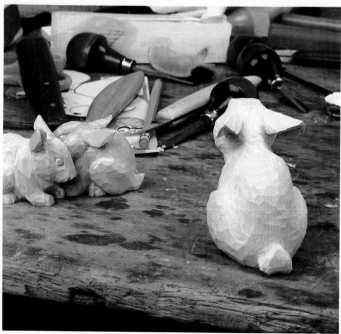 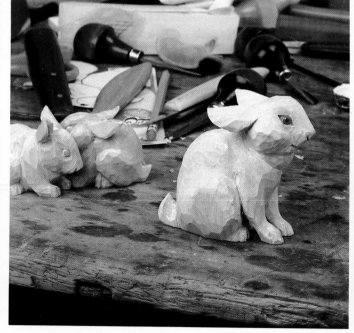

The painted rabbit.

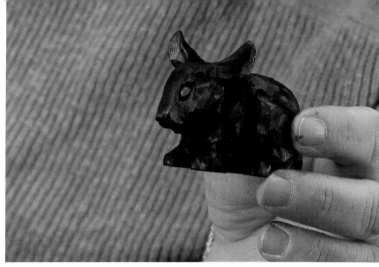

One variation on the painting is a black rabbit with some white highlights. Begin by putting some brown on the eyes, ears and the muzzle, but not the nose. While this isn't exactly true to life, it helps break up the black and is artistically correct. Use burnt sienna.

The rabbit at this point is showing some nice highlights. Next, clean the brush very well and dry it as much a possible.

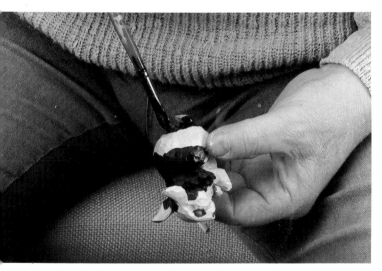

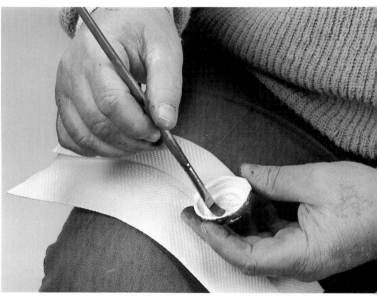

Then apply the black to the rest of the body.

Pick up a little bit of pure white pigment on the dry brush.

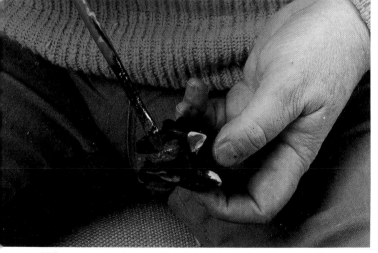

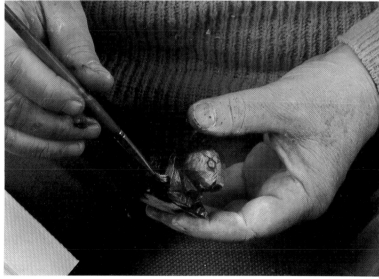

When you get near the brown spots, dip your brush in turpentine and wash in the black. If you haven't enough pigment in your brush, brush the brown areas with turpentine first, then add black to your brush and feather it in.

Apply the white lightly to the black, and brush across it. All you want to do is catch the highlights with the dry brush.

Dry your brush before picking up more pigment.

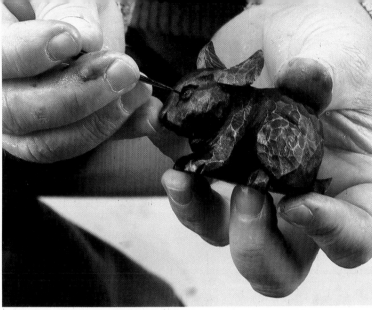

Put a black iris in the eye.

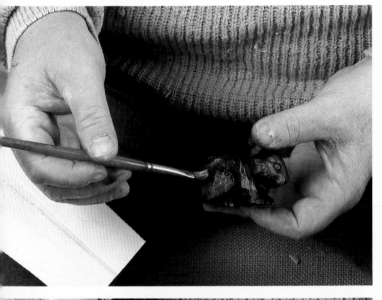

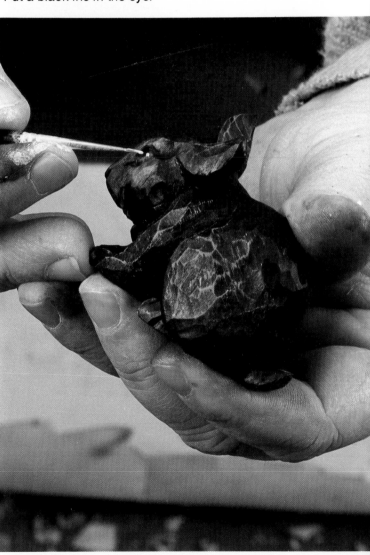

Add a white glint.

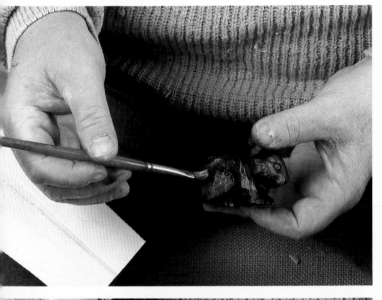

Don't do it all over. Just doing it on the hip, the tail and the ears should be enough to suggest light falling on it. It is easy to overdo this highlighting, so go slowly. Clean your paint lid when you are finished or the black will contaminate your white.

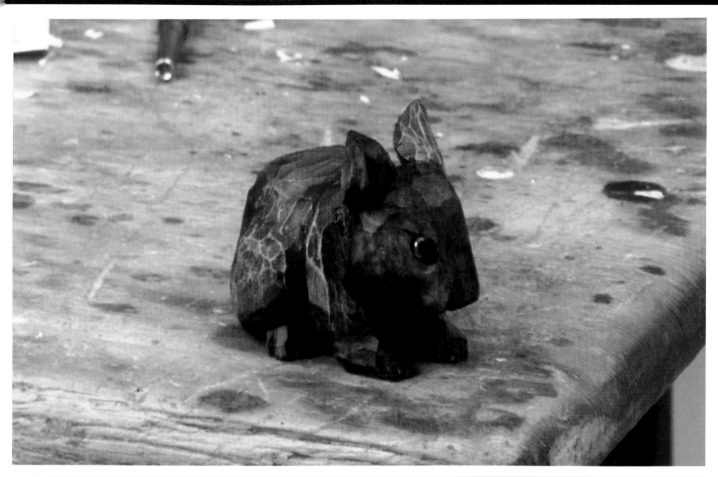

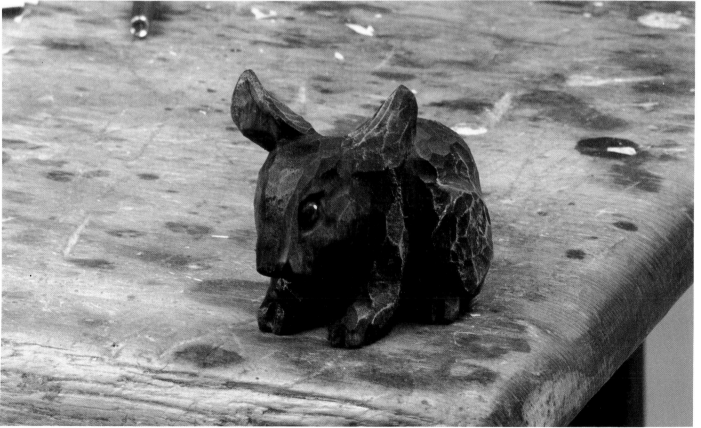

The finished black rabbit.

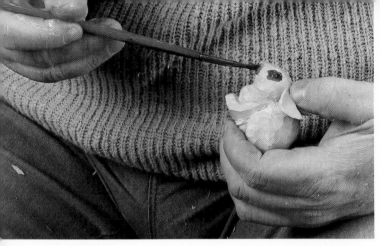

Another variation in domestic rabbits is the Dutch rabbit, a mixture of black and white. Begin by putting brown around the eyes, muzzle, underside of the tail and the inside of the ears as you did on the black bunny.

and continue over the back.

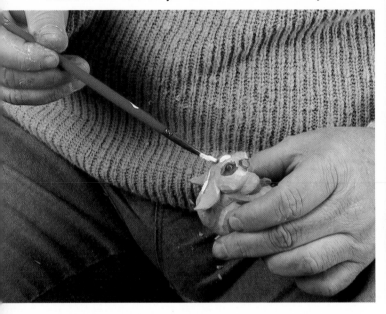

Paint the white first because you can cover up mistakes with the black if necessary. Start at the crown of the head and move down the back of the neck.

Be careful how you hold the bunny at this point. Put some turpentine over the brown so the black won't penetrate it badly if it gets on it. Then begin painting black.

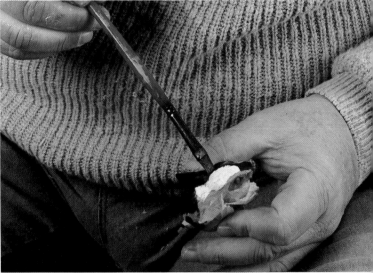

Continue with the front paws and legs...

Use extra care around the white.

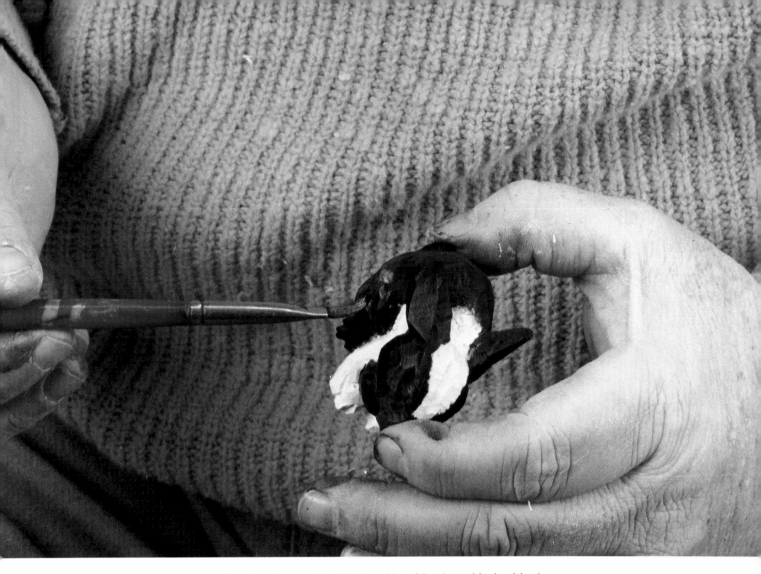

Dry brush over the black with white (as with the black bunny).

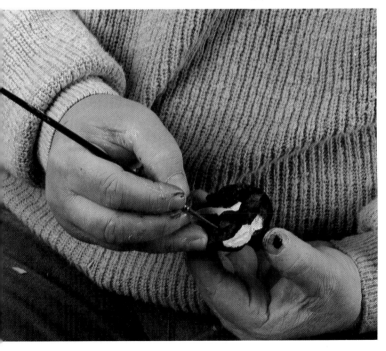

Using a small brush, paint the iris of the eye black.

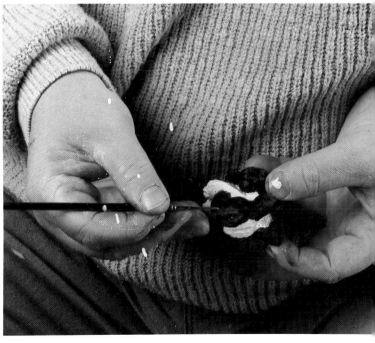

Add a white glint to the eye.

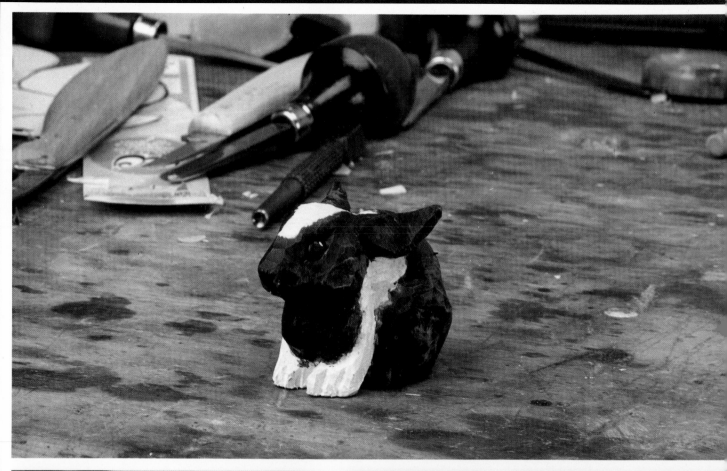

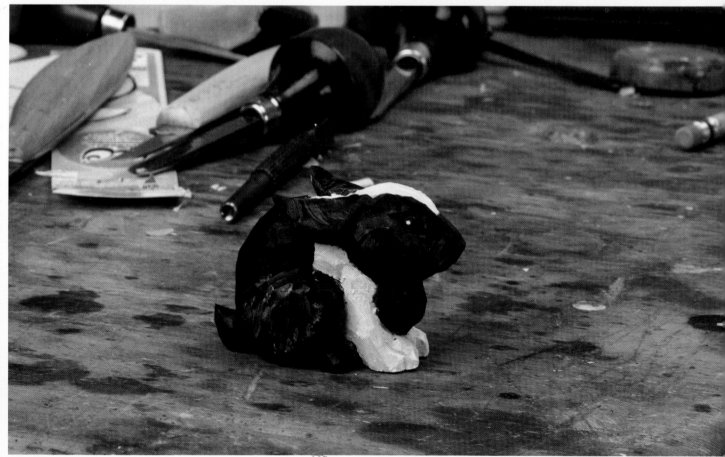

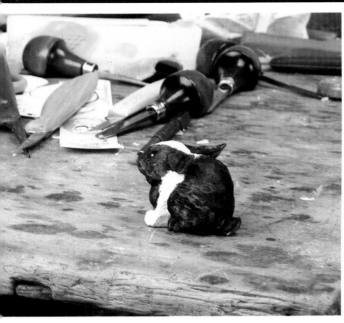

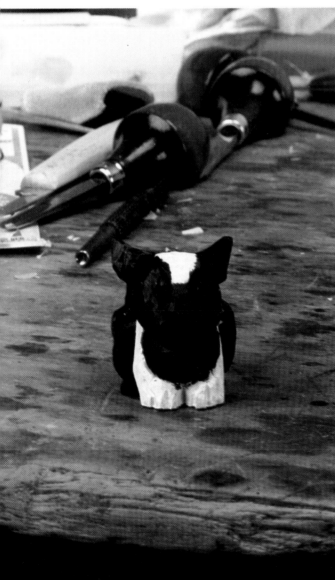
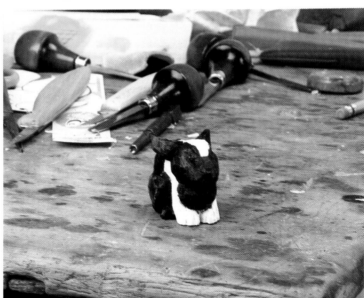

The painted Dutch rabbit.

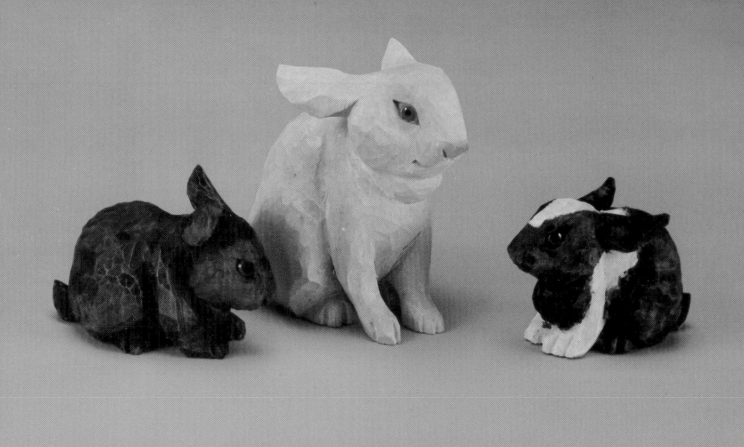

The Bunny Family